Body Stages *The Metamorphosis of*

Body Stages

The Metamorphosis of Loïe Fuller

SKIRA | **LA CASA ENCENDIDA**
CULTURA + SOLIDARIDAD + MEDIO AMBIENTE + EDUCACIÓN

CAJA MADRID
FUNDACIÓN

Cover
Isaiah West Taber
Loïe Fuller Dancing, ca. 1900
(cat. 66)

Design
Marcello Francone

Editorial Coordination
Emma Cavazzini

Editing
Doriana Comerlati

Layout
Sara Salvi

First published in Italy in 2014 by
Skira Editore S.p.A.
Palazzo Casati Stampa
via Torino 61
20123 Milano
Italy
www.skira.net

Printed and bound in Italy.
First edition

ISBN: 978-88-572-2029-1

Distributed in USA, Canada,
Central & South America by Rizzoli
International Publications, Inc.,
300 Park Avenue South,
New York, NY 10010, USA.
Distributed elsewhere in the world
by Thames and Hudson Ltd.,
181A High Holborn, London
WC1V 7QX, United Kingdom.

Body Stages
The Metamorphosis of
Loïe Fuller

La Casa Encendida, Madrid
6 February–4 May 2014

La Casa Encendida

Director
José Guirao Cabrera

Cultural Director
Lucía Casani Fraile

Cultural Coordinator
Mónica Carroquino Rodríguez

Exhibitions Department

Coordination
Yara Sonseca Mas

Management and Production
María Nieto García
Vanessa Casas Calvo

Exhibition

Curator
Aurora Herrera

Design
Estudio Aurora Herrera

Assembly
TEMA

Lighting
Intervento

Transportation
TTI

Insurance
MAPFRE

Restoration
Pilar Sedano
Carmen Levenfeld

Catalogue

Text Editing
Exilio Gráfico

Translations
Polisemia

Acknowledgements

Albertina, Vienna
Archives Hermès, Paris
Bibliothèque-musée
de l'Opéra-Bibliothèque
nationale de France, Paris
Cinémathèque de la danse, Paris
Filmoteca de Catalunya, Barcelona
Filmoteca Española, Madrid
Manuel Fontán del Junco
Rodrigo de la Fuente
Fundación Juan March, Madrid
Gaumont Pathé Archives, Paris
Marta González Orbegozo
Mercedes Ildefonso
Lobster Films, Paris
Helena López de Hierro
Maryhill Museum of Art Collection,
Goldendale, Washington
Musée d'Orsay, Paris
Musée Georges-Garret, Vesoul
Musée Rodin, Paris
Museo del Traje, Madrid
Brygida Maria Ochaim
The New York Public Library,
New York

Fundación Caja Madrid's La Casa Encendida is proud to present Body Stages: The Metamorphosis of Loïe Fuller, *an exhibition curated by Aurora Herrera that focuses on the life and work of Loïe Fuller (Fullersburg, Illinois, 1862–Paris, 1928), dancer, choreographer, lighting technician, stage designer, curator, inventor and living legend from her youth. Fuller had a profound influence on the artists and intellectuals of her time. Admired by Giacomo Balla, Marie Curie, Camille Flammarion, Henri de Toulouse-Lautrec, the Lumière brothers, Stéphane Mallarmé, Georges Méliès, Koloman Moser, Auguste Rodin, Arthur Symons and Paul Valéry, to name but a few, she transferred technological breakthroughs and scientific know-how to the stage, filed patents and produced and managed shows that toured the world.*

Her capacity to revolutionise the performing arts, intertwining knowledge and concepts from different disciplines, is a shining example of modernity that is ideally suited to La Casa Encendida's characteristic determination to explore experimental paths and new research in contemporary artistic practices. Understanding and sharing the legacy left by this "artist of artists" is a challenge in contemporary art scholarship that we have humbly accepted, gathering documents that testify to Fuller's contributions and enormous influence.

In this publication, we are honoured to include texts by Giovanni Lista, leading expert and biographer of Fuller's life and work; José Manuel Sánchez Ron, Professor of History of Physics at the Universidad Complutense of Madrid and a member of the Royal Spanish Academy of Language; Santos Casado, Professor of History of Biology at the Universidad Autónoma of Madrid; Hélène Pinet, Chief Curator at the Musée Rodin; and Simón Pérez Wilson, Associate Professor of Sociology at the Universidad Católica of Santiago de Chile. I would like to express my sincere admiration and gratitude to all of them. Finally, I am indebted to Aurora Herrera for her dedication and brilliant work, without which this project would not have been possible.

José Guirao Cabrera
Director of La Casa Encendida

Contents

11 Loïe Fuller: Art in Movement
Aurora Herrera Gómez

29 Loïe Fuller and Her Serpentine
Dance: Between Photography
and Cinematography
Giovanni Lista

55 Loïe Fuller and Auguste Rodin:
Dancer and Impresario
Hélène Pinet

75 Loïe Fuller:
Dance as Science
José Manuel Sánchez Ron

95 Living Fluxes: Insects and
Metamorphosis in Science,
Culture and the Popular
Imagination
Santos Casado

109 Hybrid Bodies, Technological
Bodies, Natural Bodies. Loïe
Fuller-Isadora Duncan: Notes
and Reflections on a Field
Simón Pérez Wilson

125 My Life and Dance
Loïe Fuller

127 Beware of Imitations!
La Ribot

129 Biographical Sketch

135 List of Works

Loïe Fuller: Art in Movement

Aurora Herrera Gómez

What is dance? It is motion. What is Motion? The expression of a sensation. What is Sensation? The reaction in the human body produced by an impression or idea perceived by the mind.

Loïe Fuller, *Ma vie et la danse. Suivie de écrits sur la danse* (Paris: Éditions l'œil d'or, 2002), p. 47

By motion she was not only referring to the dancing body but to the motion of the light, colour and silk as well. She danced light, colour, costumes, and through motion her body fused into a visual image. Fuller conceptualised an image in motion created by multicoloured lights, playing in a perpetual motion of silks.

Sally R. Sommer, "Loïe Fuller", *TDR/The Drama Review*, vol. XIX, no. 1, TISCH School of the Arts, New York University (March 1975), p. 54

Loïe Fuller, born Marie Louise Fuller (Fullersburg, Illinois, 1862–Paris, 1928), was a dancer, choreographer, lighting technician, researcher, inventor of special stage effects, art curator, filmmaker, member of the French Astronomical Society and businesswoman. Moreover, from a very young age she was also a living legend; she was hailed as the muse of Art Nouveau and in 1900 had her own pavilion, designed by Henri Sauvage, at one of the most important events of the day: the World's Fair in Paris.

Admired by Stéphane Mallarmé, Auguste Rodin, Arthur Symons, Henri de Toulouse-Lautrec, Koloman Moser, Pierre Roche, Raoul Larche, Théodore Rivière, Jules Chéret, Umberto Boccioni, Giacomo Balla and Anton Pevsner, among many others, Fuller exercised an enormous influence on the artists of her day.

Her fascination with science as a vehicle for experimenting with stage design led her to establish friendships with many prestigious scientists of the time. Some of them became her esteemed teachers; in other cases she worked with them in their laboratories or in the space she created to carry out her own experiments. William Crookes, Camille Flammarion,

Marie and Pierre Curie, Thomas Alva Edison and Charles Henry all formed part of her scientific universe.

Fuller's creative interests spanned two fields of research which, in her day at least, were apparently unconnected. On the one hand she was fascinated with "popular" performing arts, such as vaudeville, light operas at small-time theatres and minor dance genres such as the skirt dance, which was all the rage in the late-19th century; on the other, she was drawn to science and experimenting and took a passionate interest in new technologies. This confluence of native and chosen universes gave rise to an extraordinary person, whom we might describe nowadays as "modern".

Fuller represents an amalgam of body, dance, technology and nature. She did away with the set and redefined the stage, plunging it into darkness to focus the stage production on the body concealed by the costume, in constant motion and picked out by changing light effects. This approach completely altered the narrative dimension of the theatrical act.

Loïe Fuller performed with neither scenery nor words, opting for a purely experiential mise-en-scène based on repetitions of dualities: action and reaction, inside and outside, absence and presence. Thus, she strove to captivate her audience with the action itself, stripping away the relationship between space and time.

Fuller recognised that the performance space held its own dynamic energy and she rejected all forms of linear discourse that might occur on the stage. She fused the body in motion with the light that enveloped it, with the space in which it performed, with colour and with the power of emotion and expression in their purest state, creating a new theatrical formula that was ahead of its time then and remains as valid as ever today.

Her influence on contemporary art cannot be overestimated, even if it has not always been recognised. After she died, the dance world cast her aside as a symbol of the avant-garde—in fact the obituaries published in the press mistakenly described her as a disciple of Isadora Duncan or Ruth Saint Denis. Nevertheless, today Loïe Fuller remains an "artists' artist", capable of motivating and inspiring creators across interdisciplinary fields.

Loïe was introduced to the entertainment world as a child, after her family moved to Chicago. During this early phase of her career on stage she played small roles, reciting poems or singing in light operas. Although she made her debut as a dancer in a variety show in 1887, the only time she ever received dance training was after she travelled to Europe in 1889, when she was twenty-seven years old. From that point on, she lived between Europe and the United States.

In the autumn of 1891 she returned to the United States to play the part of Imogene Twitter in Fred Marsden's production of *Quack Medical Doctor* at the Boston Opera House. It was then that she hit on a brilliant idea for her role in a hypnosis scene: she donned a great chemise with wide trailing sleeves that she could move easily with her arms and hands and added a series of moving coloured lights which emphasised the mise-en-scène as they fell on the costume, creating a surprisingly hypnotic atmosphere. This performance marked the beginning of her research into stage design and opened up a new field of choreographic experimentation in the theatre world.

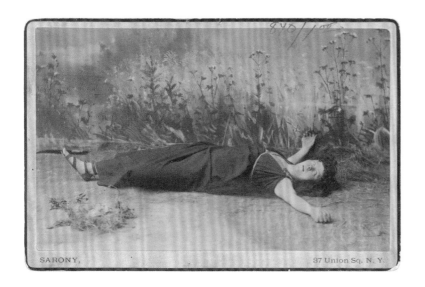

Napoleon Sarony
Loïe Fuller, 1887
(cat. 16)

Only six months later, Fuller presented her greatly acclaimed "serpentine dance", astonishing audiences by concealing her torso beneath a voluminous robe that she held in her hands and waved repeatedly, tracing a sequence of gestures over and over again, from one to ten, under red, blue and yellow lights. The dance ended with a final ray of yellow light emerging from the darkness and crossing the back of the stage.

The costumes, which she designed herself and patented, fulfilled a symbolic rather than decorative function. They were a fundamental element of the performance, the protagonist of the mise-en-scène, playing a crucial role in the formal expression of the dance.

Photographed on countless occasions and for different supports, Fuller was always fascinated by the idea of freezing motion in a fraction of a second. Although these photographs could not capture the expressive use of colour in her dances, they do provide us with a record of her life and career.

By contrast, Fuller always refused to be filmed: she believed that cinema was incapable of conveying the materiality and sensory complexity of her dances. Inimitable, she nevertheless had numerous imitators—only some of them with her consent—and her serpentine dance was therefore performed across the world, achieving an unprecedented popularity that was soon augmented by the early filmmakers, fascinated as much by the movements and coloured light effects as by the expressive capacity of the dance. Fuller's first imitator was Minnie Renwood Bemis, whom Loïe sued for plagiarising her dance in 1892. Over the next four decades, scores of other imitators emerged on every continent, including Annabelle Whitford Moore and Crissie Sheridan, filmed by Thomas Edison; Miss Illys, Alice Lethbridge, Mrs. Abeta, Valentine Petit, Mlle Bob Walter and Miss Lina Esbrard, filmed by Alice Guy; and Rose Mountain, Thérèse Rentz, Allice Gallina, Alice Fuller, Ida Fuller, Bessie Clayton, Ada Delroy and La Goulue, to name but a few.

The serpentine dance was an international popular phenomenon that took our ancestors by storm: mechanical devices were developed to be able to see the movements more clearly, films were screened at cinemas and holograms were devised to capture the dances of Fuller's imitators. All in all, we might say that it was the origin of what we now call performance art, based on a dance that inspired numerous creators in interdisciplinary fields.

Fuller never received any formal training in the art of dance, but she did have a profound knowledge of popular theatrical forms. Moreover, she forged her avant-garde experience out of a rare and thrilling combination of dance and theatre, on the one hand, and scientific and spiritualist knowledge—so influential during her formative years—on the other. But this required overcoming numerous obstacles. First and foremost, a woman dancing alone on the

stage, freed from the constraints of the academic canons that dominated 19th-century dance, was a target for sexist, religious, technical and political prejudices. But Fuller's strength lay precisely in that extraordinary experimental courage that shines through in all of her work.

After travelling to Europe in the autumn of 1889, having been hired by the Royal Globe Theatre and the Gaiety Theatre Company in London, Fuller remained in England for almost two years, during which time she came into contact with the new artistic, scientific and spiritualist trends of the day.

In some of her writings she expresses her admiration for William Crookes, a greatly respected British physicist and chemist who enjoyed international acclaim. Crookes was an eminent figure in the scientific community and must therefore have also been an important personality in London's intellectual circles. He discovered thallium, invented the Crookes radiometer, carried out extensive research with cathode ray tubes and was a pioneer in the study of plasmas. He also invented one of the first instruments for studying nuclear radioactivity, the spinthariscope, and published numerous papers on spectroscopy. But there is a key aspect of his career that may well have had a decisive influence on Fuller's subsequent work, and her creation of the serpentine dance in particular: Crookes was also a reputed spiritualist, a scholar of phenomena such as the movement of bodies at a distance, luminous appearances, phantom figures and hypnosis, all observed in a distinctly scientific spirit. Thus, the stage set that Fuller proposed for the famous hypnosis scene in *Quack Medical Doctor* on her return to the United States in 1891 reflected the knowledge she had acquired in Europe.

In 1896, keen to find out how radioactive materials might be used to create special stage effects, Fuller visited the laboratory that Edison had just set up in Menlo Park, New Jersey, to study radiation. There, she discovered the power of phosphorescent materials, radioactive salts and X-rays, and was able to observe a series of experiments conducted with light boxes: boxes painted with radioactive oils that emitted light for several minutes through transparent lids.

Years later, Edison was forced to close the lab as the researchers contracted diseases because of the radioactive substances. However, far from abandoning her experiments in view of the obvious health hazards associated with them, Fuller decided to set up her own lab. Her dream became a reality in 1905 when she bought a small warehouse on Rue Raynouard, in the Passy quarter of Paris, and turned it into a laboratory.

At Passy, Fuller embarked on her own research into the substances she had discovered at Edison's lab. The purpose of her experiments was to find beauty in nature through the knowledge and principles of light: "Beauty in the search for beauty." She therefore financed the entire research process as a pure quest for knowledge rather than in the hope of any financial gain.

At work in her lab, Fuller recorded and named approximately 13,000 colours which changed under polarised light in constant motion, demonstrating the potential of the artificial compared with the natural.

Fuller applied this same idea to her theatrical creations, gradually dematerialising her body on stage in a quest for abstraction through a type of hybridisation or metamorphosis that

offered a novel interpretation of dance through lighting and the partial or total concealment of the body on stage—presence and absence united by moving light, colour and silk.

In her "Lecture on Radium" Fuller explained her research into light effects and described her experiments in combining and decomposing light, adding that what really interested her was experimenting with radioactive materials.

Camille Flammarion, an eminent astronomer, reputed spiritualist and admirer and friend of Fuller, helped her to turn her laboratory into a professional facility, choosing scientists who would complete the gaps in Loïe's research knowledge. Thus, under Flammarion's supervision, Fuller worked with renowned opticians, chemists and physicists, in particular with Charles Henry, friend of Flammarion and Georges Seurat and a figure rarely mentioned in Fuller's biographies. Henry's work on the aesthetics of forms and the factual knowledge surrounding the perception of art had an enormous impact on the artists of the day. A mathematician and disciple of Carl Friedrich Gauss and Jósef Maria Hoene-Wroński, he discovered and produced several theories about colour and its dynamogenous or inhibitory effects. He also explored the symbolic value of colours and directions in space. His theories on an ascending line from left to right to reflect pleasure, and a descending line from right to left to reflect pain, were subsequently exploited in filmmaking, especially in action movies. Although Henry's influence on Fuller has never been studied in depth, some of his teachings were undoubtedly reflected in the choreographies that Loïe created in the 20th century.

Emilia Cimino-Folliero, a well-known suffragette, biographer of Rodin and admirer of Fuller, was the principal witness of the relationship between Rodin and Fuller. As Hélène Pinet notes in her essay in this catalogue, this relationship was based on a series of mutual interests.

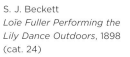

S. J. Beckett
Loïe Fuller Performing the Lily Dance Outdoors, 1898
(cat. 24)

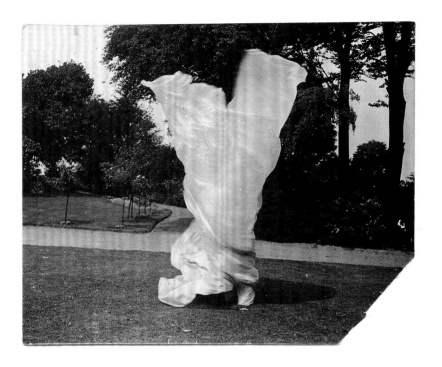

For example, we know that Fuller was extremely keen for Rodin to sculpt her portrait, and it was allegedly Rodin who gave her the idea of building her own pavilion at Paris' 1900 World's Fair, opposite the one he himself had built on the left bank of the Seine, just as Gustave Courbet and Édouard Manet had done for the 1867 World's Fair. Other sculptors, like Raoul Larche, Théodore Rivière and Pierre Roche, had already expressed their interest in the figure of Fuller in motion, and we know that Loïe sat on several occasions for Rodin. However, the master never finished a portrait of the dancer, which is not that surprising when we consider that his sculptures focused on the human body, while Fuller's dances concealed the body and gave precedence to abstraction.

Rodin's milieu, which Fuller soon began to frequent, brought her into contact with numerous figures of the day, including important American collectors, European aristocrats who popped up in artists' circles, and interdisciplinary artists like Eugène Druet, Rodin's official photographer. In Paris she also came to know researchers like the aforementioned Flammarion and Pierre and Marie Curie, with whose daughter Ève, a renowned pianist, she subsequently developed a close professional and personal relationship.

Throughout her career, Fuller acted as an agent for other artists, as in the case of Rodin in the United States, for whom she initially organised exhibitions and then promoted the creation of the Maryhill Museum of Art, which opened in 1940 and currently holds a large number of the French master's works.

In 1902 Fuller presented her company of young dancers for the first time, marking the beginning of another important stage, both in her career and her personal life. A combination of narcissism, a desire for posterity and the dissolution of her persona in multiple mirrors, reflected in her followers, this company would become Loïe's alter ego as well as a possible school to guarantee her legacy. Fuller directed and choreographed several works for her company, which broke up and reformed on several occasions during the first half of the 20th century.

Among the company's countless tours, one of the most famous was the one that ended in Cairo in 1914, where Fuller posed for photographs in front of the Sphinx at Giza, draped from head to foot, including her face, in a bridal gown and train. In the 19th century, devotees of magical thinking regarded this monument as a "living image", seeing that woman with a lion's body as the guardian of female mythology, astral knowledge and astronomy. The symbol fused beauty with the lion's ferocity and strength, and the fact that Loïe chose to have herself photographed next to it suggests that she saw it as a mirror image of herself. However, the photographs in which she appears with her company next to the sphinx are mostly photomontages—with no attempt to correct the scale—composed out of the solo shots of Fuller with the mythological creature. These photographs of Fuller with her company emphasise her leadership qualities and the adoration of her disciples. Indeed, Fuller was photographed on countless occasions as an object of mystical worship and adoration.

In 1914, Fuller created the "dance of hands", which was clearly influenced by Rodin's numerous sculptures of clasping hands, emphasising the hollows between them. Hands are a complex part of the human anatomy where many of the body's systems meet, and they

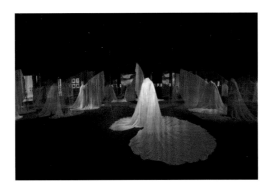 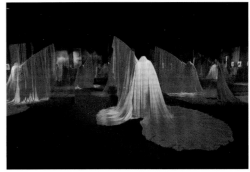

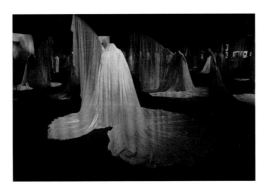 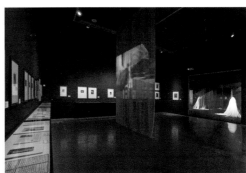

 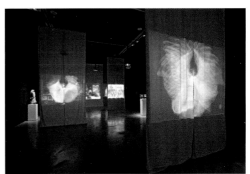

Images of the
exhibition Body
Stages: The
Metamorphosis
of Loïe Fuller, *held*
at La Casa Encendida

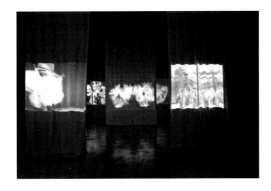 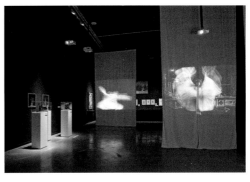

also have a great symbolic power that has evolved over the ages to express wishes and feelings or indicate negatións. A hieratic immobile figure rooted to the centre of the stage, Fuller made her hands seem to have a life of their own, lending a distinctly hypnotic quality to her performances.

Fuller's activities during World War I merit their own consideration. A fervent defender of the wounded and of humanitarian causes, she wrote articles, organised whip-rounds, was photographed at the front and was involved in initiatives to raise funds for soldiers, as when she responded from the United States to a plea for help from Queen Marie of Romania.

But as with so many other avant-garde artists of the 20th century, Fuller's heyday came to an abrupt end with the Great War. After the armistice, she found herself in the same situation as many fellow artists, plunged into a period of uncertainty due to pressing cultural and economic problems.

After working as art and lighting director for other artists' shows, in January 1925 Loïe Fuller underwent surgery for breast cancer. During her convalescence, she was photographed on several occasions. These harrowing images of the doctors removing her stitches after a radical mastectomy invite a dual reflection. On the one hand, they evidence a total abandonment of her mutilated body, which she deliberately exposed to the public view in a highly contemporary stance; on the other, they demonstrate a narcissistic vision of the persona who had herself photographed even in intimate moments in which most of us would shy away from the cameras.

Loïe Fuller passed away in Paris in 1928 after contracting pneumonia, possibly as a result of a reduced immune system provoked by her illness. She was cremated and buried at Paris' Père-Lachaise cemetery, not far from the remains of Isadora Duncan, who had died in tragic circumstances the year before. Her funeral was attended by Raymond Duncan (Isadora's brother), Gabriel Astruc, Ève Curie, Kate Fuller, René Bizet and Damia, among other leading lights of the Belle Époque.

Following her death, Gabrielle Bloch—also known as Gab Sorère—Loïe's long-term secretary, agent and lover, took over the management and coordination of Fuller's company, which nevertheless soon split into two groups. Paradoxically, this circumstance proved beneficial to the dissemination of Fuller's legacy, leading to performances around the globe until 1950.

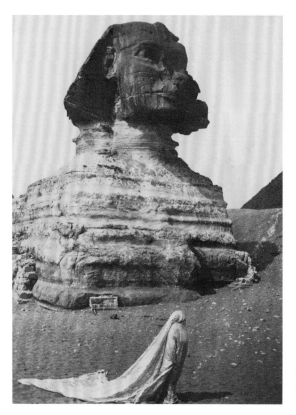

*Loïe Fuller Dancing
before the Sphinx
at Giza,* 1914
(cat. 87)

In 1934, six years after Fuller's death, Gabrielle Bloch directed the film *Le Lys* [The Lily], which offers an overview of all of Fuller's theories. The lead character in the film is the dancer Amelia Baker, whom Gab decided to film in the open air, in a garden, thus removing every theatrical illusion of the traditional indoor stage. In keeping with the etymology of garden, or *Garten* in German, as an enclosure, she replaced the stage with a fenced in, delimited outdoor setting, giving rise to a kind of pantheistic communion between the serpentine dance and nature.

Harry C. Ellis
*Loïe Fuller after Undergoing
Surgery to Remove a Breast
Tumour*, 1925
(cat. 103)

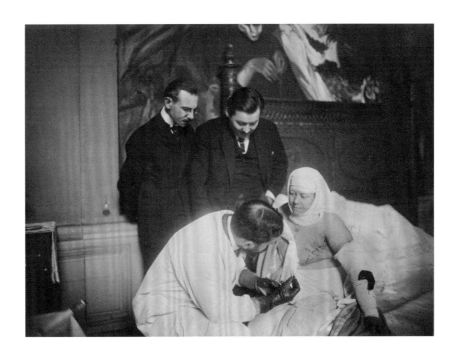

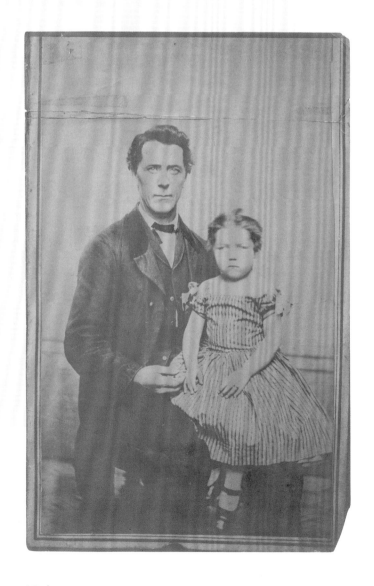

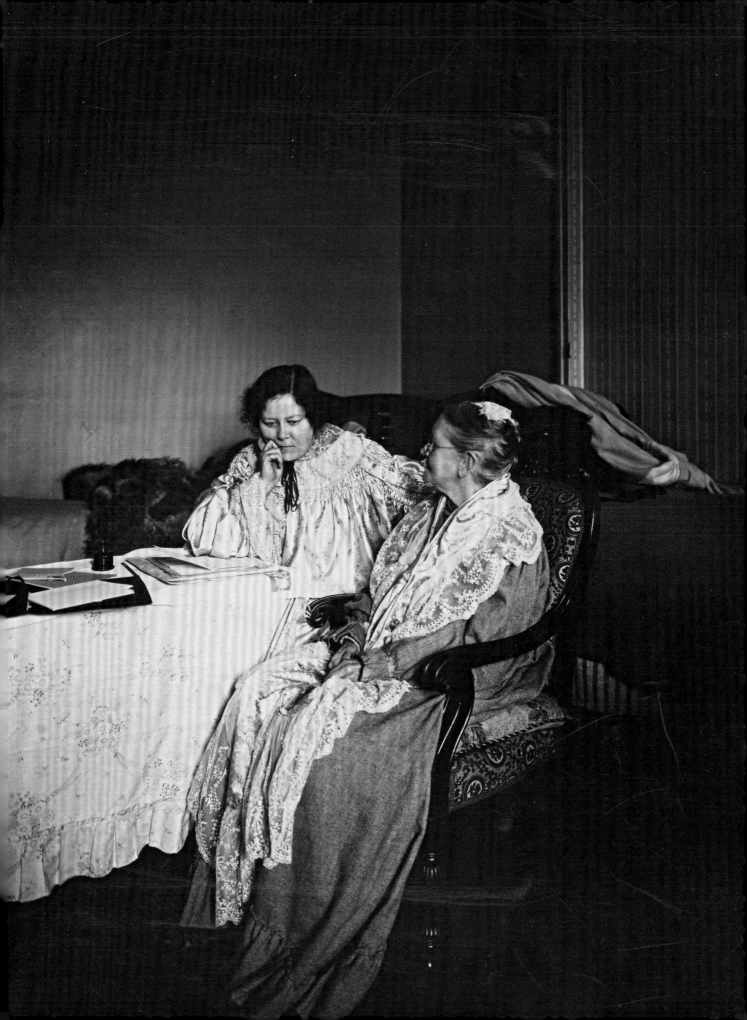

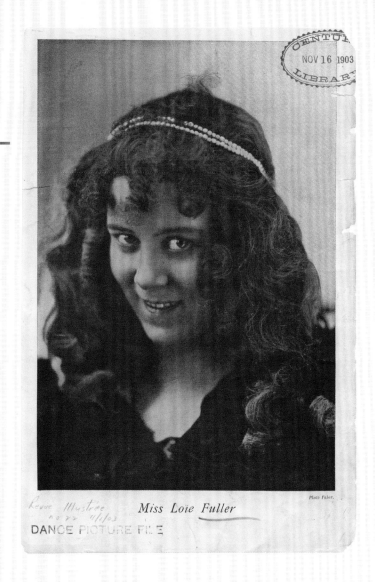

Faber
Loïe Fuller in San Francisco,
ca. 1894
(cat. 5)

"Loïe Fuller/Cléo de Mérode.
Philosophie de la danse.
Origine des danses sacrées"
[Philosophy of Dance. Origin
of the Sacred Dances], 1903
(cat. 4)

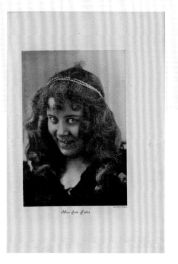

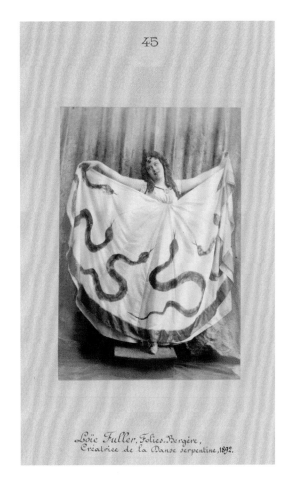

Portrait of Alice A. Weston,
ca. 1902
(cat. 8)

Illustrated Supplement of
L'Écho de Paris, 1894
(cat. 10)

Loïe Fuller. Folies Bergère, 1892
(cat. 11)

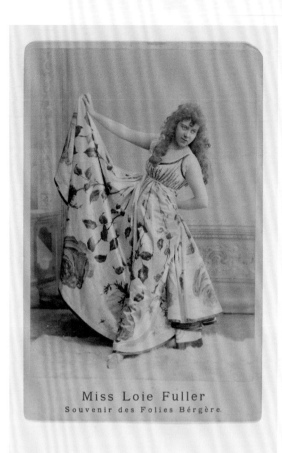

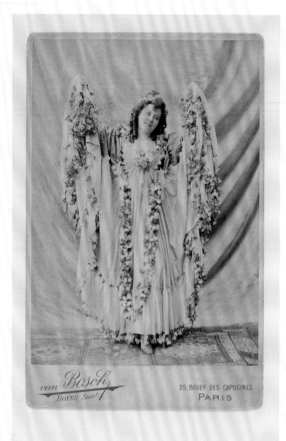

Miss Loïe Fuller, ca. 1893
(cat. 13)

Van Bosch
Loïe Fuller, ca. 1892
(cat. 12)

*Loïe Fuller in Costume for
the Butterfly Dance*, ca. 1895
(cat. 14)

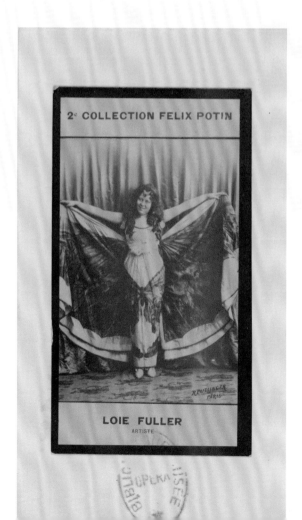

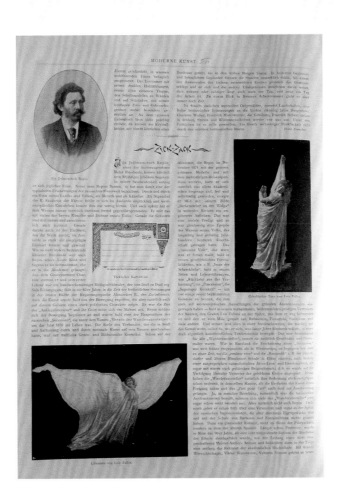

"Griechischer Tanz von Loïe Fuller"
[Loïe Fuller's Greek Dance], n.d.
(cat. 15)

Langfier
*Loïe Fuller Performing the
Butterfly Dance*, 1896
(cat. 21)

Butterfly Dance, ca. 1898
(cat. 20)

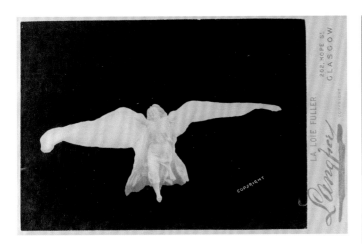

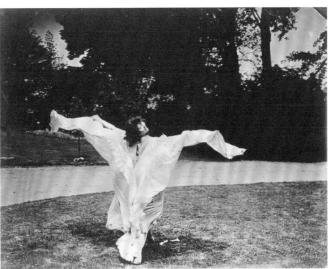

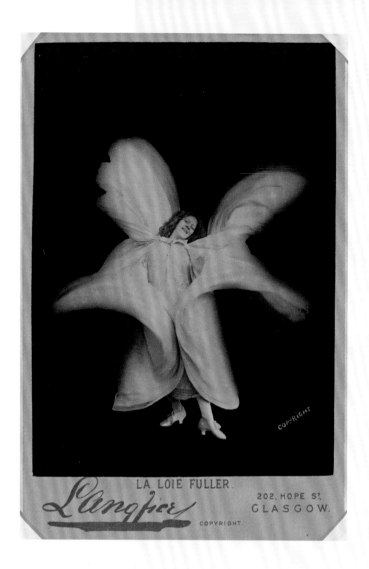

Langfier
Loïe Fuller: Serpentine Dance, 1893
(cat. 19)

Théodore Rivière
White Dance, 1898
(cat. 22)

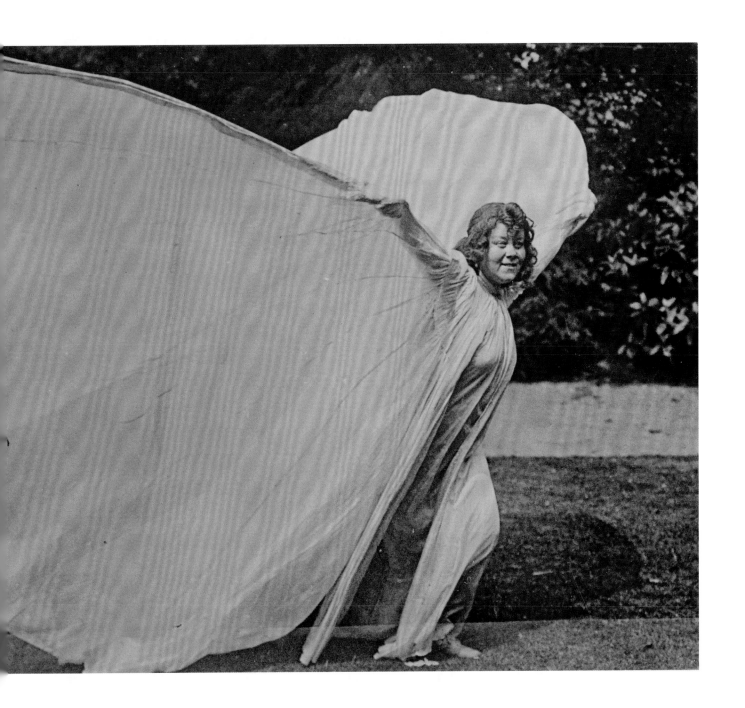

Loïe Fuller and Her Serpentine Dance: Between Photography and Cinematography

Giovanni Lista

Loïe Fuller, the first major innovator in the history of modern dance, was a true revolutionary in that she rejected the sovereign role occupied on the stage by the physical body of the dancer. She was, in fact, a dancer whose body was denied, perpetually concealed by her veils, whose movements were designed to construct a completely different picture of femininity, both alluring and immaterial. The erotic, spiritual and idealised connection between the female body and the veil has survived through the ages, from the ancient Roman ceremonies of the *velificatio* down to the skirt dance of the late-19th-century London music hall. But Fuller radicalised and inverted this connection to give the veil sole primacy. She thus invented the multimedia spectacle, by treating her own body purely as a machine for expression. Enrico Prampolini, the Futurist theoretician of scenography, wrote that with her serpentine dance Fuller introduced "the first attempt at a dance in which the plastic and rhythmic attitude of the gesture is subordinated to its chromo-luminous aspect, a performance in which the form and matter of the dance are not imprisoned in the rhythmic experience of the human body. Now dance was finally able to escape from its simple purpose, the expression of human plasticity, and to project itself into the surrounding space and participate in the action on stage".[1]

By getting rid of stage sets and plunging the stage itself into darkness, Fuller transformed the theatrical space through the invention of the luminous body. She thus redefined the relationship between the stage and the auditorium as one of fascination. She eliminated all the narrative or thematic elements of the theatrical performance and presented a spectacle of pure forms in continuous transformation in which the undulations of her veils, as well as their changing colours, signified an "art of movement" that gave rise to a new aesthetics. The particular characteristics of this art were meandering lines, mobile and supple forms, flowing and abstract patterns in which the intense and dynamic repetition of these patterns eventually brought a new form into being. The disappearance of the actual body of the dancer was equally necessary so that the veil itself could become the expression of the body. Line, movements and repetitions that brought about the metamorphosis of form, all together composed a new female body, one that was physically absent, lacking in definition, presenting itself as the pure life of possible forms, as a kind of twin of spiritual energy. It was "the poem detached

[1] Passage quoted in Giovanni Lista, *Loïe Fuller, danseuse de la Belle Époque* (Paris: Stock and Somogy, 1994). Expanded second edition published in Paris (Hermann Danse, 2006).

from all the apparatus of the scribe", as Stéphane Mallarmé wrote. Fuller married the natural world to the dream world in a symphony of lines, forms and colours. The "poetry in motion" of the serpentine dance was expressed through the continuous rippling and undulation of the veils, turning dance into an art of interlacing surfaces that were seen as the place where forces come together to take on physical expression. Form here was no longer sought after as the creation of a resemblance to something else, but rather as the manifestation of generative forces that escaped all formal stereotypes.

Movement was also embodied, perhaps with even greater intensity, in the gradations of the projected colours. Their imperceptible yet continuous alteration made even more movements seem to appear on the surfaces of the veils, evoking nature itself, or states of mind, or natural phenomena. It was a movement generated not by the changing of position in space, but purely by the loss of focus, or the splitting up or intensification of the beams of light. The most ancient human sensations, the most primitive visual experiences, were thus brought onto the stage: the growing light of dawn, the fiery glow of sunset, the brightness of day, the moonlight at night, the sparkle of a diamond, the vividness of a flower and the brilliance of a star, but also the pallor of terror, the red of anger, the dull hues of melancholy or the increase or decrease in depth of colour which marks the different states of matter and indeed accompanies the passage from life to death throughout the universe. The serpentine dance conveyed to the spectator a breath of pantheistic mysticism through the most sensitive language possible in the theatre. Colour, as well as the movement of the veil, enabled Fuller to express the exhilaration of life, understood as a sphere of perpetual transformation. As a multimedia spectacle, playing with coloured light and the perpetual movement of her almost intangible veils, the serpentine dance could not be captured in her day by the most modern techniques for fixing a visual image: neither photography nor cinematography were capable of grasping, whether on photographic plate or on film, the swirling movement of Fuller's veils.

There are very few photographic images that show Fuller performing her serpentine dance. Most of the images we have were posed shots taken in the studio, since the technical capabilities of late-19th-century cameras did not allow them to capture the swirling, luminous veils of the stage performance. Some other photographs show her outdoors, often in a garden, but these were simple demonstrations of the movement of her veils, with none of the lighting effects she used on stage. There do exist three, extremely rare, photographs taken during her performance at the Théâtre de l'Athénée in Paris.[2] In this show, which opened on 14 September 1901, she presented three new dances: *Danse fluorescente* [Fluorescent Dance], *Tempête* [Tempest] and *Archange* [Archangel]. That is to say, it was just after the 1900 World's Fair, when she was at the height of her fame, that she finally allowed herself to be photographed in a live performance. Acclaimed by poets and artists,[3] the serpentine dance was already a visual archetype, represented as a stylised line-drawing by poster artists and designers. But these three photographs are unprecedented as visual depictions. This was in fact the first time that the mechanical eye of the camera had come so close to the truth of the swirling shapes and lights that constituted Fuller's dances. These images document the en-

[2] The three photographs, whose author is unknown, belong to the collection of the Bibliothèque nationale in Paris.
[3] See Giovanni Lista, "Loïe Fuller et les symbolistes", *Revue d'esthétique*, no. 22 (December 1992), pp. 43–52.

ergy expended by the body, convey the élan of its movement through space and restore something of the aesthetic aura and lyrical fascination of the choreography of abstract shapes that is the essence of the serpentine dance. Although in order to shoot these images the photographer had to eliminate the usual blackness of the stage, he did succeed in capturing Fuller's sweeping gesture "on the move".

In the first image, depicting the dance called the *Tempête*, Fuller is shot in profile, with her body arched and her head thrown back to form a line that echoes the giant circle of the veil, whose curve in turn evokes a breaking ocean wave. This veiled form in motion, perceived as an intangible being, is the outcome of an abstract development. The image itself appears as a pure surface of vibration and light. The dancer's gestures are not chosen to represent a sensibility, a mood or a feeling. Fuller conceived her dance from the outside, making a careful choice of what she allowed to be seen and what the public perceived, that is, planning the exact interactions between the concealed action of the body, the movement of the veil in space and the perceptions of the spectator. The serpentine dance, a foreshadowing of abstract art, relies on the immediate perception of the visual form, in which the events on stage are identified with the material of the gesture itself. The outward expression is not intended to represent a felt interiority. Instead, it is actualised in a metamorphosis that raises the material of the veil to the level of the visibly corporeal.

We know that the other two images are photographs of the archangel dance, as Fuller appears mounted on a pedestal, imitating the traditional iconography of the archangel Michael, who is always depicted on a pinnacle or pillar. This elevated position allows her to use very long veils, which she extends across the entire space of the stage with the help of long rods. The tunic that covers her body flares into a triangle with its base towards the stage, while the veils that she agitates with the rods form an inverted triangle. Fuller moves the mass of the veils upwards or downwards in a continuous movement that in the photograph becomes a swirling blur. As in the case of the serpentine dance, the downward rotation of her

Loïe Fuller Dancing the Archangel Dance at Paris' Théâtre de l'Athénée in September 1901 (Bibliothèque nationale de France, Paris)

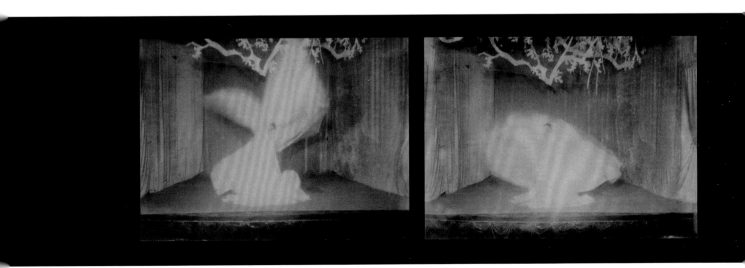

arms also had a practical purpose: it kept the blood circulating in her arms, thus enabling her to hold the veils firmly over lengthy periods.

Fuller thus agreed to have her dances be photographed as soon as the camera had acquired the technical capabilities needed to capture the moving image in the darkened space of the stage. Why then did she not also want her dances to be filmed? After all, the relation to the moving image was fundamental to all her work. The novelty of her serpentine dance derived precisely from her close involvement with the most everyday aspects of scientific progress, particularly electric light, which she combined with colour in order to create a new aesthetic language. The close proximity of her work to cinema makes this absence of any filmed instance of her performance all the more striking. In fact, in her eyes the cinematic image could never replace the reality of live theatre.[4] Her rejection of cinema was doubtless encouraged by a perspective typical of the culture of her time, imbued as it was with Wagnerianism and Symbolism. Indeed, those who argued for art as something spiritual, able through its fluid, intangible nature to redeem whatever lies at the root of the poverty and harshness of reality, also viewed the eye of the camera as incapable of grasping anything more than mere physical matter. Fuller must moreover have seen cinema as a medium that gave an artificial fixity to the world of appearance and light, undermining the live act of creativity.

On the other hand, the emerging cinema very soon took an interest in the serpentine dance. As a temporal art, cinema's development was guided by a fundamental implication of its ontological status: to capture movement either as a sequence or as a whole. Dance films were extremely sought after at the time, and the serpentine dance, a spectacle of movement that used the veil to create abstract forms and flowing, lyrical figures, was perfectly suited to cinema. The serpentine dance featured a kind of movement which, firstly, had no utilitarian end in view and, secondly, was characterised by the continuous transformation of a physical form. Many of Fuller's imitators did pose for the film cameras. Mass-produced, the resulting films could be viewed in the kinetoscopes springing up on urban boulevards. While many of these films have been lost, enough of them survive to show how greatly cinema was fascinated by the serpentine dance, and how much it was inspired and nourished by the aesthetics of movement that this dance incarnated.

The short films from this period in which we can view dances "in the style of Loïe Fuller" mainly present two types of images. One consists of energetic movements performed by dancers who leap around in a rigid and somewhat arbitrary manner. The other presents fantastic scenes that combine narratives like those of Georges Méliès with Fuller's type of visual magic in order to create highly lyrical effects. But neither type ever reaches beyond a kind of vaguely defined expressiveness, and they all fail to achieve the power, precision and complexity of Fuller's dances, which were always composed of purely abstract movements devoid of narrative meaning. Indeed, as her work evolved, Fuller came to embody a dance that was diametrically opposed to the liberation of the body through movement. Her serpentine dance, expressed through the fluid and continuous movement of the veil, in fact relied on the constrained and repetitive gestures of a body that was itself concealed, as can clearly be seen in the photographs taken on the stage of the Théâtre de l'Athénée.

[4] Her refusal to be filmed is mentioned explicitly in a passage of her memoirs. See Loïe Fuller, *Ma vie et la danse. Suivie de écrits sur la danse*, text selection and introduction by Giovanni Lista (Paris: Éditions l'œil d'or, 2002).
[5] For a listing of 143 films showing the serpentine dance, see Giovanni Lista, *Loïe Fuller, danseuse de la Belle Époque*, op. cit. (note 1).

An analysis of the corpus of films featuring the serpentine dance made during the decade of transition from the 19th to the 20th century shows that there were various different ways of performing, and of filming, a serpentine dance.[5] Cinematically speaking, for the first few years the approach did not alter. The dancer was always filmed in a static shot and from the same angle. The camera was mostly positioned at right angles to the dancer, who was usually framed in a long shot, occasionally in medium shot. The eye of the camera recorded what took place in the confined space of the stage without adding any kind of cinematic effect. Although the dance was performed against a black background, for technical reasons the cinema of the period needed the stage to have diffuse lighting and a brightly lit floor. These films are consequently very different from Fuller's performances, which took place in a completely dark space where the beams of light directed towards her veils made her seem an unreal and ghostly presence, something between a phantom and a dream image. Various attempts were made to resolve this contradiction between the black background of the stage, against which the silhouette of the dancer appeared, and the brightly lit floor, which destroyed any illusion. Some of the films made by Thomas Edison made use of an inclined plane behind the dancer, which would be partially illuminated and function as a transition between the background and the stage floor. In other films, the dancer was shot in close-up, so that the illuminated stage floor did not appear. Still others show that attempts were made to reduce the brightness of the lighting by means of black carpeting on the stage floor or by retouching the film. But the floor is still always visible as a grey surface on which the shadow of the dancer can almost always be seen.

The addition of colour to these films is equally problematic. The advances made by Fuller herself in this area are so dramatic that the beginning of colourised film is in fact closely related to the serpentine dance. Among the forerunners of colourised film is a photo flipbook, *La danse serpentine de Loïe Fuller* [Loïe Fuller's Serpentine Dance], published in 1894. The dancer photographed for it was clearly just one of Fuller's imitators, but it was the fantastic character of this dance that dictated the need to use colour. That same year, *Annabelle Serpentine Dance*, shot with the dancer Annabelle Whitford Moore, was colourised by the wife of Edmund Kuhn, a photographer from the laboratories of Edison's Kinetoscope Company. She painted the completed film directly, using cotton and tiny brushes. Since varnish could not be applied to the flexible celluloid, she used liquid aniline-type dyes, applying a half-dozen solid colours, ranging from orange to crimson, against a uniform dull red background. The first colourised film ever made thus sought to express the hypnotic power of the serpentine dance through the use of chromatic values.

The following years saw a proliferation of colourised films of serpentine dances in Europe and the United States, with enormous popular success. These were sometimes colourised by machine and sometimes by hand, using a brush. In the former case, the effects could be monochrome or involve colour variation. In the latter case, the work was often done in the laboratory, using simple brush strokes to apply vertical bands of colour randomly across the moving veils. When this work was carried out by true creative artists, especially in Spain and Italy, the colouring could be very delicate, with remarkably subtle chromatic variation.

The first two films made in the laboratories of the Kinetoscope Company accurately convey the content, techniques and forms of the serpentine dance. They were both shot on the same day, 10 August 1894, and with the same dancer, Annabelle Whitford Moore. One, titled *Annabelle Butterfly Dance*, depicts a kind of fairytale tableau on the theme of the butterfly woman, a frequent subject on the popular stage of the day. Wearing a costume whose pattern suggests a butterfly's body, along with wings and antennae, the dancer moves in a lively, impulsive manner, kicking her legs up rhythmically and energetically and holding in her hands two rods attached to the veil of her skirt. Thus, she spins as if in a waltz, with a joyful expression on her face as she gyrates around the stage.

The other film, *Annabelle Serpentine Dance*, has no such allegorical significance. In this case, the dancer wears a simpler, more voluminous costume. The veil is wrapped tightly under her bust and fastened at the waist, forming an organically unified ensemble that partly masks the dancer's body. As she holds the two rods in her hands, she exposes her bare arms and thus expresses her physical individuality both with her own body and through a sort of dialogue with the forms produced by the veil. Much of the time her face is expressionless and seemingly absent, reflecting the dancer's concentration on the shapes created by the veil, which she must produce in a completely prearranged way. The veil seems to possess its own kinetic autonomy, for example when it forms a moving arc whose diameter is the equivalent of the upright body of the dancer. She plunges her arms towards the ground to make the veil evoke the curving petals of a flower or bends her torso backwards to suggest the flight and the wings of a butterfly. This makes the volume of the veils expand both vertically and behind her back, rather than simply being whirled round in a circle.

As suggested by the titles of these two films, both made and distributed in 1894 by Edison's Kinetoscope Company, at the time a fairly clear distinction was made between the serpentine dance, seen as a separate genre because it was a new dance, and "allegorical" dances using fabrics for effect, with a long tradition that had given rise to many kinds of performances. In all its previous versions—the dance of the veils, the allegorical ballet, the skirt dance, cloak dance, scarf dance, butterfly skirt dance, the Turkish Manola dance and the fan dance, from China or Korea—the floating veils merely followed the dancer's gestures in order to add an extra dimension, whether aesthetic, erotic, kinetic or symbolic. They therefore functioned as an embellishment, whereas in the serpentine dance the veil took on an expressive life of its own, choreographically independent of the dancer: it is the veil that creates movement and produces abstract forms in space. The serpentine dance shows the spectator the coming into being of form, its continuous change and perpetual renewal, and the endless process of creation and recreation that is the symbol of life itself. Fuller rejected the prevailing anthropomorphism of traditional dance, and presented what was primarily a theatrical performance of ontogenesis.

This clear distinction between the two genres was later abandoned, once the serpentine dance became synonymous with any dance using veils, and there was some crossover between the serpentine dance and allegorical dances using fabric for effect, illustrating subjects such as the flower woman, the insect woman or the butterfly woman for symbolic or

narrative purposes. Many films thus adopted the term "serpentine dance" for what were in fact allegorical dances of this latter kind. A film entitled *Loïe Fuller*, for example, is a borderline case: shot in 1905 for Pathé Frères, it represents the transformation of a bat into a dancer who then performs the serpentine dance. Wrongly attributed to Lucien Nonguet, this film was positively worshipped by Joseph Cornell, who thought that the dancer in the film was Fuller herself, although in fact the performer was just one of her imitators.

In contrast, the serpentine dance developed formally in a way quite unrelated to these allegorical dances. In 1894, Fuller's imitators began to appear in a new kind of costume, modelled on hers. It consisted of a very large circle of fabric, attached directly to the dancer's neck and reaching down to her feet. The armature needed to support the veil and make it move was provided by the arms and the rods that they held straight out. Other abstract shapes also enriched the repertoire of forms created by the veil as it moved through space. For example, the dancer could display herself either in profile or full face, lifting one arm at a time in a series of alternating asymmetric gestures, first stretching downwards and then immediately upwards again. To increase the complexity, the dancer could cross the veils over each other by reaching forward and down with one arm while extending the other behind her head to make a circular arc in the opposite direction, forming a kind of cross.

In another film shot by Edison's Kinetoscope Company in 1895, also called *Annabelle Serpentine Dance*, this new type of tunic made of chiffon, tied at the neck and loosely covering the body, became even more voluminous. The rods concealed inside it were now even longer, allowing the dancer to extend the movements of the veil much farther, unfolding it in all directions, particularly upwards and forward. The anatomy of the body thus disappeared while the face became impassive and expressionless, almost detached from the swirling of the veils. Only the head showed that a human body was involved, and the dancer herself was no longer an actress performing a role. She seemed instead to be a technical expert displaying three-dimensional forms whose relief was emphasised by the bands of colour added to the film. With one arm, and then the other, she performed a sequence of movements to produce an effect of multiple rotating discs. Concave and convex surfaces alternated, suggesting seashells and whorls, while the continuous coiling of the fabric blurred all the individual phases of the transitions. The rotary movements gave the impression of several simultaneous coils, entwined in an extremely complex way, with symmetrical effects sometimes alternating, sometimes uniform. The tight framing of the image magnified the kinetic quality of each form.

Another film that Edison made in 1897 with dancer Crissie Sheridan features a somewhat different costume. Sewn onto the sleeve from armpit to wrist, the veil looks like a membrane that extends the body of the dancer, forming a continuous line with the flexible, medium-length bamboo rods. This combination creates a flowing, natural and continuous line that immediately recalls typically Art Nouveau designs. The dance is filmed from the front in a single plane, framed tightly, and the absence of colour in the film makes us realise both how necessary the colours are and how artificial the postproduction colourisation actually was. The veil no longer appears as a two-dimensional outline, but as a volume that

empties and then billows out in space. Its three-dimensionality, both concave and convex, is strongly marked by the interplay of light and shadow. This purer, more dramatic sense of volume is intensified by the great size of the veil: it literally swallows up the dancer's body, which disappears inside it. The completely bare stage increases the ghostly effect of the performance.

Another dancer, Ameta, refused to be swallowed up by her veil in this way. Her *Serpentine Dance* was filmed in 1903 by F. S. Armitage with wider framing and right angles. Wearing a patterned evening gown that leaves her arms bare, Ameta has only two veils, attached to her waist and sewn onto two rods. The independence of her body, which does not merge into the veils in any way, is also emphasised by her gown, which copies the fashion of the time. This outfit thus maintains the dancer's individuality. The rods are very long and flexible, and hold the fabric in tight curves that suggest the contours of ocean waves. The dance begins with the shape of a budding flower: the rods, held together under tension with both hands and bent back in an arc over the head, are suddenly released by the crouching dancer, initiating her movement with the opening of the flower.

Other short films exhibit a great deal of variety. In a 1900 film whose title is uncertain, sometimes attributed to Paul Nadar and sometimes to Alice Guy, cinema makes its first technical contribution to the serpentine dance. Shot in close-up, the body of the dancer, Bob Walter, seems to occupy the entire visual field of the camera. The performance she gives is appropriate to her stage presence and the emotional complicity she establishes with the eye of the camera. Her playful, rhythmic gestures have none of the merely athletic or mechanical quality of many other films of the era. She occupies the whole space, moves about rapidly, jumps in the air, creates a variety of forms, shows the veils in profile, makes ever smaller sideways leaps, and ends in an extraordinary position, backwards, with her knees on the ground, arching her body so as to smile at the camera. Through the vitality of her body and the pleasure she finds in the dance, she resists being overwhelmed by the veil. But it is especially the close-up shots possible in film that, by encouraging the dancer's individual self-expression, define her visible opposition to the abstraction of pure form in movement.

A serpentine dance filmed outdoors in 1897 by Luca Comerio for Lumière features a costume in a heavy fabric with an extended veil held up by rigid, medium-length rods. The dancer, in this case the Italian Teresina Negri, performs on a trestle stage set up in a street in the centre of Rome. She is filmed with a static shot, in three-quarter view with a low angle, in order to accentuate the dynamism of the dance. As a result of the weight of the fabric the veil loses the effect of billowing volume, but it multiplies the folds, that seem to ripple endlessly around the dancer's body. Being shot outdoors, the dreamlike aspect of the serpentine dance is destroyed, but here there is an attempt to compensate for this through the mannerist expressionism of the colourisation: the iridescent colours of the rainbow are used along with shading and shifting from warm to cool tones, sometimes inside the same form. The costume has been coloured using a brush, producing constant variations in colour and tonal intensity, ranging, for example, from purplish red to yellow or from yellow to pale blue against a sepia background, all intended to simulate the ever-changing effect of the lumi-

nous colours. Teresina Negri uses every part of her body, although she does not kick her legs up, choosing instead to extend them horizontally. Her dance, which also includes crouching and contorted kneeling positions, achieves complete harmony between the body, the movement in space and the continuous, ever-changing enfolding of the veil.

This same mannerist expressionism in the use of colour characterises the final section of *Farfalle* [Butterflies], another Italian film produced in 1907 by the Roman company Cines. The final episode, coloured by hand with a brush, presents a ballet of butterfly women with very elaborate colouring, in a mixture of orange and blue or alternating purple, yellow, blue and green. It seems that Italian films were the only ones to adopt this brightly-coloured mannerist expressionism, recalling the "Gallé effect" that Fuller achieved in her serpentine dance by means of the interaction of two differently coloured beams of light on her veils. The perpetual movement of the folds of fabric meant that the angle of incidence of the coloured beams of light varied continuously, thus producing the same impression of transparent, changing colours as in the glass pastes made by Gallé.

The use of colour modulation alone, without any alteration of the naturalism of the image, reached a unique level of virtuosity in the work of the Spaniard Segundo de Chomón, who used pastel and neon tints for his colourisation, thus imparting an effect of great delicacy to the images. His most advanced exploration of the film camera's ability to render movement is probably *La création de la serpentine* [The Creation of the Serpentine], made in 1908 for Pathé Frères. After a narrative prologue using trick effects, very popular at the time, seven dancers appear in a completely empty space to perform a dance choreographed with veils. They arrange themselves in different patterns on the stage, and on two different levels of a scaffolding masked in black. Segundo de Chomón used several different methods to exaggerate the abstract character of the dance. First, he made use of his famous Camera Number 12, with which he could shoot in reverse. Next, the dancers look identical, with the same costumes, the same wigs and the same expressionless faces. This loss of individuality

Danse fleur de lotus
[Lotus Flower Dance],
1896
(cat. 41)

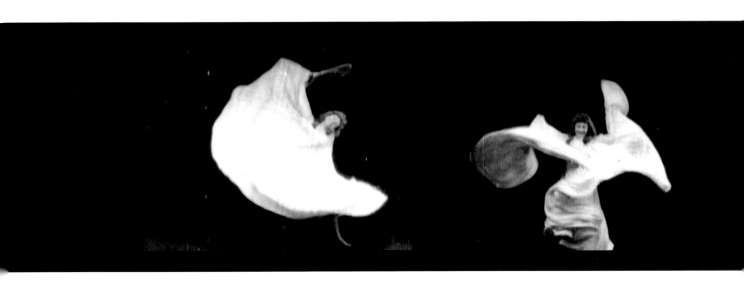

increases the effect of abstraction produced by the pure forms of the veils in motion. In effect, the choreography makes the image seem multiplied in order to achieve the duplication and continuity of a single overall form most effectively. In other words, the individuality of each form is erased in order to emphasise the existence of one single form embedded in the depth of the stage. At times, the choreography has all the figures moving at once, not in order to reconstruct a sequence of linear movements through space, as Muybridge and Marey sought to do, but to combine into a whole new figure in motion: one gesture appears in the foreground, another on the first level up above it, and so on. Thus, each of the gestures is repeated by others in close proximity, displaying a different stage of the same gesture.

The majority of these short films portray the primitive stage of the serpentine dance as it was performed at the time,[6] sometimes merely as an interlude during shows aimed at mass audiences. The images thus only document the gradual introduction of a number of key features that defined the serpentine dance as a genre: the large size, texture and shape of the veil, the role of the body and its degree of visibility, the length, flexibility and shape of the rods, the order of appearance and the quantity of luminous colours and, lastly, the orientation of the gestures and movements. Some dancers, for example, appeared in profile so as to emphasise the effect of rising waves or exploited the symmetrical up-and-down movements of the arms to diversify the forms of the veil in space. All these variations derive from the work previously done by Fuller, who had already taken her own aesthetic creativity as far as it could go. Fuller was the only dancer to advance beyond the level of the "dance of the veil" to achieve an art of the intangible, focused on movement, abstract sculptural form and luminous colour.

In fact, none of these short films gives a true picture of what we know from the writing and iconography of the time about Fuller's own work: a degree of virtuosity that enabled her to fling the veils up to a height of six meters; a patent for rods with curved tips that would eliminate any breaks in the outline of the veil; a team of lighting technicians operating mobile projectors that eventually reached more than one hundred persons; a profusion of every possible shade of colour with an infinite amount of kaleidoscopic effects; the stage in utter darkness, completely covered with deep blue draperies so as to absorb the projected colours; the search for ever more delicate textures for her raw silk veil; or the use of mirrors to multiply and dematerialise the images on the stage. The shortcomings of the films of the serpentine dance did prove one thing: Fuller's performances of the art of the veil could not be replicated by other dancers nor by cinema, which lacked the technical capacity to capture on film the fantastic character of her dances.

The filmmakers of her day were forced to admit that it was technically impossible to film Fuller's highly sophisticated interpretations of the serpentine dance. For Fuller too, cinema could offer nothing but an impoverished travesty of the magic of her performances. Thus, when she went to see Edison, it was not to ask him to film her, but rather to ask for advice in order to increase even further the wealth of colour and lighting effects in her dances. Her experimental methods took her far beyond the limits of the cinema, despite the deep and unrecognised affinities between the approaches of both forms of art.

[6] The short films analysed in this text are all incorporated into the film *Loïe Fuller et ses imitatrices* [Loïe Fuller and Her Imitators] by Giovanni Lista, produced by the Cinémathèque de la danse in 1994; second expanded version produced by the CNRS, Paris, 2006.

Although the serpentine dance and cinema seem to be based on the same aesthetic principle—using the interception of light by a material object to generate new art-forms—they were in fact radically unalike. In cinema, the beam of light is the technical means through which the work of the filmmaker—who has already fixed on the film the relationship between light, bodies and shadows—is made manifest after the fact. Cinema is thus the product of the combination of an already imprinted reel of film and a blank screen, connected together by a beam of light. But the serpentine dance united these two objects, the film and the screen, in one concrete element: the veil. The difference between these two arts resides primarily in the difference in the quality of the beam of light. In cinema, this light already includes the forms that are to be given life on the screen. The cinema's light is already inhabited, and is revealed over the course of the film. But the veil of the serpentine dance captured a light that had never yet met an image: the forms arose out of its own movements. In her dances Fuller made productive use of light to generate three-dimensional forms. Cinema is in a sense superfluous, since the film is already there, before ever being shown, forever captured on celluloid. What Fuller presented was the performance of a visual score made of light and colours in which movement was the generative force, producing visual forms out of nothing. She gave the spectator, in real time and in one place, a seat in front of the miracle of creation through the encounter of light and the veil.

Another difference between cinema and the serpentine dance has to do with their use of their respective materials. When the beam of light touched Fuller, her raw silk veil did not present an impenetrable surface, like that of the cinema screen. Instead, it seemed to let itself be penetrated by the light, to the point of becoming intangible and a source of luminescence in itself. The hypnotic effect of the dance was due to the fact that the veil irradiated the light: it was as if the image on the stage was emitting the beams of light, whereas cinema depends much more explicitly on the principle of projection.

Danse des papillons
[Butterfly Dance], 1896
(cat. 42)

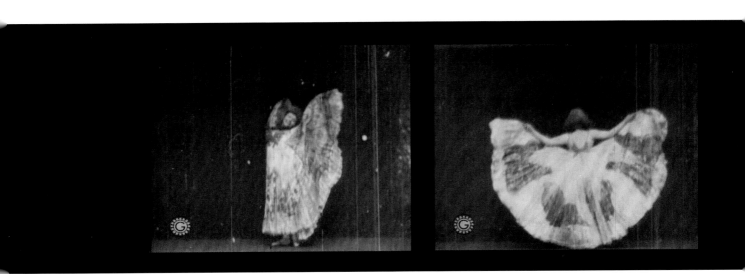

The parallel between the serpentine dance and experimental photography, which sought to capture movement in a way very close to cinema, is also relevant. Firstly, it was by adopting a photographic technique common at the time, the black background against which the physical presence of the subject was outlined, that Fuller isolated her own illuminated image on the darkened stage. The effect was much like that of the foreground shot in cinema, a kind of visual self-assertion, while the choreographic shapes created by the veils also functioned to amplify the image. Then, as the veil gave visible form to the trajectory of the gesture, it made it perceptible as a kind of path or spatial displacement, somewhat like the chronophotographs made by Marey, who photographed all the successive phases of the movement of a body in space. Moreover, the veil revealed this trajectory as the manifestation of expended energy, as in the Futurist photodynamics of the Bragaglia brothers.[7] The flowing pathway traced by the veil was a visual expression of the gesture as the memory of its own progression. Also, the way in which the form was manifested had something essentially photographic about it. The subjects depicted during the dance, such as the butterfly, the cloud, the dragonfly, the wave, the lily, the bird or fire, suddenly appeared against a visually disorienting backdrop. Everything was in motion and yet the figure only materialised for a few moments, as if in a click of the camera shutter, before vanishing again into a swirl of luminous colours.

Loïe Fuller managed to create this effect by terminating her gestures with a continuous, repeated, rippling movement of the veil, like the swimming movement of a jellyfish, which enabled her to gradually expand each form until it became the choreographic figure she sought to achieve. In the utterly dark space of the stage, repeating the same gesture on the same spot gave the impression of a still photo: out of the dark there crystallised a visual, moving, abstract image in which an intelligible form was present. The gesture functioned, in short, as a kind of flash-bulb lighting up the form. This strobe-lit form was also sharply defined and equally generated by the contour created by the black space of the stage. The audience thus experienced the performance in a state of expectation, following the movement of the veil as a gradual heightening of form culminating in the brief incarnation of a vibrant figure, barely glimpsed before it vanished again. In other words, the source of the mysterious fascination of Fuller's serpentine dance was ultimately the confrontation with the living chaos of primordial nature that creation myths describe. The audience first saw only veils, endlessly rippling, undulating, swelling, collapsing and reforming. Then, at some point, in the

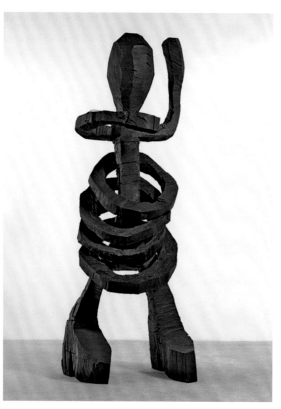

Georg Baselitz
Loïe Fuller, 2013
Bronze
138 ³/₈ x 51 ¹/₅"
(Galerie Thaddeus
Ropac, Paris)

continuous swirling that dazzled every eye, there suddenly appeared a recognisable figure, only to vanish just as suddenly, as if swallowed up. Fuller's performances thus presented her audiences with the enigma of visual perception itself, guiding them to experience its manifestation—that is to say, to confront the mystery of the inexplicable force that brings form into existence and materialises being in the midst of nothingness. Cinema, on the other hand, had to live with the technical reproducibility of the image inherent to the medium, as well as with the smaller scale of the screen, which made the luminous veils seem all the more solid. In this way, by condensing the forms in movement of the costume and exaggerating the colour and light elements, it converted the serpentine dance into something like an imaginary sculpture in progress: an abstract form endlessly modelling and generating itself in space.

[7] See Giovanni Lista, *Cinéma et photographie futuristes*, exh. cat. (Paris: Flammarion, 2008).

LE THÉATRE

DIRECTION ET RÉDACTION : 24, Boulevard des Capucines. | PUBLICITÉ : DUHAMEL et CUMMUNAY, seuls concessionnaires 10, Boulevard Montmartre. | CONDITIONS DE L'ABONNEMENT : PARIS : 1 an... 40 fr. ; DÉPARTEMENTS : 1 an 44 fr. ÉTRANGER (Union postale) : 1 an... 52 fr. | ABONNEMENT ET VENTE : Librairie du FIGARO, 26, rue Drouot.

PALAIS DE LA DANSE. — Mlle CHRISTINE KERF. — *La Cigarière.* — TERPSICHORE

◄ ÉDITEURS : Manzi, Joyant & Cie, 24, Boulevard des Capucines, Paris. — PRIX NET : **2** fr. ; Étranger, **2** fr. **50** ►

E. Bosanquet
Loïe Fuller Waltz, 1902
(cat. 26)

Arsène Alexandre
"Le Théâtre de La Loïe Fuller"
[The Theatre of La Loïe Fuller],
1900
(cat. 23)

Pierre Roche
Loïe Fuller, ca. 1900
(cat. 25)

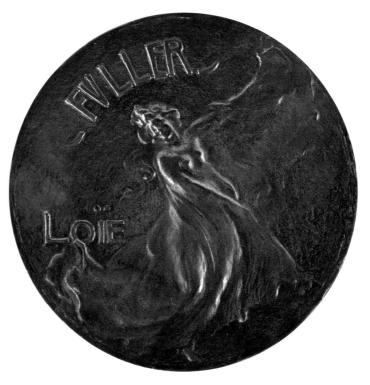

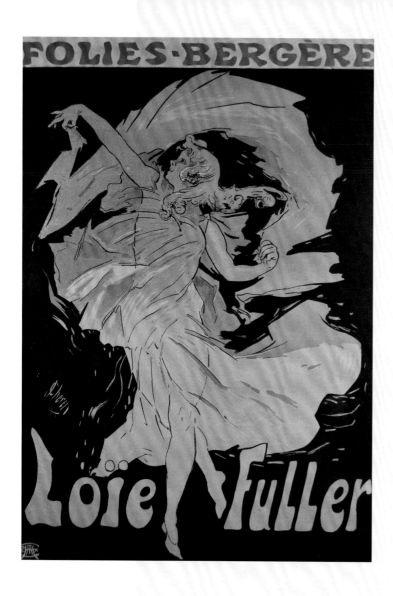

Jules Chéret
Folies Bergère. Loïe Fuller, 1897
(cat. 27)

Loïe Fuller
Le Langage de la danse
[The Language of Dance], n.d.
(cat. 28)

LE LANGAGE de la DANSE.
————————

L'alphabet complète à: marcher, mais il y a plusieurs façons de marcher.

Courir, mais il y a différentes façons de courir.

Sautiller, sauter, bondir, tourner, se tordre, se balancer, glisser, apprendre à avoir le coudet la tête libres, et par dessus tout, de la liberté dans les gestes des bras et des mains.

Expressions qui doivent être en harmonie avec le reste: tomber, s'agenouiller, se coucher, se rouler, jeter, pousser, tirer, toutes ces choses sont l'A. B. C. de la Danse.

D'abord le langage est simple et donne l'impression de l'assemblage des lettres de l'alphabet dans les plus petites phrases, et ceci fait, un grand progrès est déjà accompli. Ensuite viennent les gestes plus importants, les plus grands gestes, et les gestes nobles, jusqu'à ce que l'on ait atteint le plus haut point d'expression.

Ce point, où l'on peut rendre l'expression de: La Mère au pied de la Croix, attendant le lever du jour pour donner son âme à son fils crucifié - Ceci - est le plus haut point que peut atteindre l'expression humaine.

Ou la résignation du Christ - le plus haut point d'expression divine. -

Avec le rythme, ceci serait de la danse.

Par Rythme, je veux dire une série d'expressions mises en semble et formant une cadence, une phrase de grande

C 9-227 .7

2.

musique spirituelle.

En y apportant le temps nécessaire, vous obtiendrez des expressions unifiées, comme la cadence d'une douce mélodie.

Ceci est le langage de la Danse.

C 9-227. 8

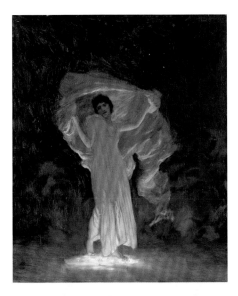

Jean-Léon Gérôme
Loïe Fuller, 1893
(cat. 30)

Jean-Léon Gérôme
Loïe Fuller, 1893
(cat. 31)

Jean-Léon Gérôme
La Danse [The Dance], 1893
(cat. 32)

Loïe Fuller
Théorie de la danse
[Theory of Dance], n.d.
(cat. 29)

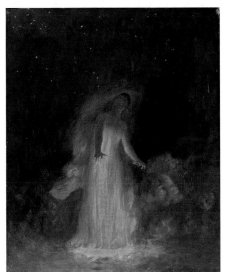

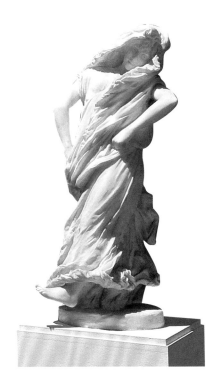

THEORIE de la DANSE.

Quand une danseuse a quitté la scène, l'esquisse de sa danse, si on pouvait la voir, devrait être aussi parfaite dans sa symétrie qu'un morceau de dentelle.

Par exemple: Un rond pour être rond, doit être complet. Ainsi devraient être les formes et les rythmes dans les mouvements et figures dans lesquels la danse a été enregistrée sur la scène.

Ne rien faire et bien le faire devrait être une nécessité dans la lumière et l'ombre d'une danseuse, comme un moment de silence dans un orchestre, ou un moment d'arrêt dans le vent qui souffle. –

On devrait savoir ce qu'ils désirent et veulent dire, et puis – le faire. –

Le corps, lequel par inexpérience exprime très mal en premier, ce que la danseuse ressent, vous surprendra par ses résultats après des "effets" et du "temps".

Pour apprendre à marcher il faut du temps, de même que pour apprendre à tenir une plume.

Patience, volonté, persistance et efforts, ont pour résultat l'expression de l'âme, exactement comme la graine nécessite du temps pour devenir un arbre.

L'A. B. C. ou alphabet de la danse est de se mouvoir dans le chaos. Peu à peu les mouvements s'intensifient, et, avec le temps, tout le monde est surpris.

2.

Etre musicale est la fondation même de la danse – pour la multitude.

Une grande danseuse n'a pas besoin de musique, car la musique la limite dans ses mouvements et ce n'est pas la liberté entière, et la plus grande danseuse a besoin du plus de liberté possible.

Le talent suit n'importe qui. Le génie crée quelque chose de nouveau, et qui n'a jamais été vu ou connu auparavant.

Mais toutes les choses doivent être créées de choses existant déjà, en mettant ceci et cela ensemble; car chaque chose que nous voyons ou connaissons, ou ne voyons et ne connaissons pas, proviennent de la terre noire que nous foulons et des objets et du cerveau de l'homme.

Rembrandt a donné au monde une nouvelle école de peinture, mais il s'est servi de vieilles choses.

Le talent se sert seulement des créations des autres, et pourtant le talent nous prend par surprise; quand la surprise est apaisée le temps nous montre à l'horizon la différence entre l'effet produit sur nous par la surprise et la vérité.

Dans la danse, comme dans toutes choses, il y a le talent, le grand talent, et le génie. – Nous confondons souvent l'un avec l'autre, mais le temps nous découvre la vérité, car le temps est l'horizon de la vision.

Dans le royaume de la danse, commençons d'abord par les enfants. Ils ont ent l'A. B. C., et pourtant ils nous

3.

font apercevoir comme le langage doit être beau quand l'alphabet est appris.

Pour former une danse d'une expression ressentie, l'expression de cette sensation en mouvements rythmés, cela serait une – danse.

Une danseuse peut prendre une pose, comme l'on voit sur un vase rose, mais il serait plus à point pour apprécier de ce que la danseuse, sur le vase, représente, et puis l'exprimer comme on le ressent, ce serait ainsi bien plus vrai et réel.

Un enfant peut exprimer l'amour d'une fleur

Une mère " " de son enfant
Un enfant " " la joie
Une femme " " l'extase
Une femme " " le chagrin
Un enfant " " la tristesse
Un enfant " " le plaisir du mouvement
Une femme " " la joie de la paix
Une vieille femme " la tranquilité
 etc... etc... etc...

Et pour transformer toutes ces sensations en danse, cela veut dire une musique visuelle – Musique des yeux.

Pour danser – danser – danser encore – sentir – ressentir – penser, et pouvoir, mais ne pas étudier ces mouvements, et quand quelqu'un vous demande, comment vous l'avez fait, répondez: "Je ne sais pas, car je ne sais pas ce que j'ai fait, j'ai seulement fait ce que je ressentais.

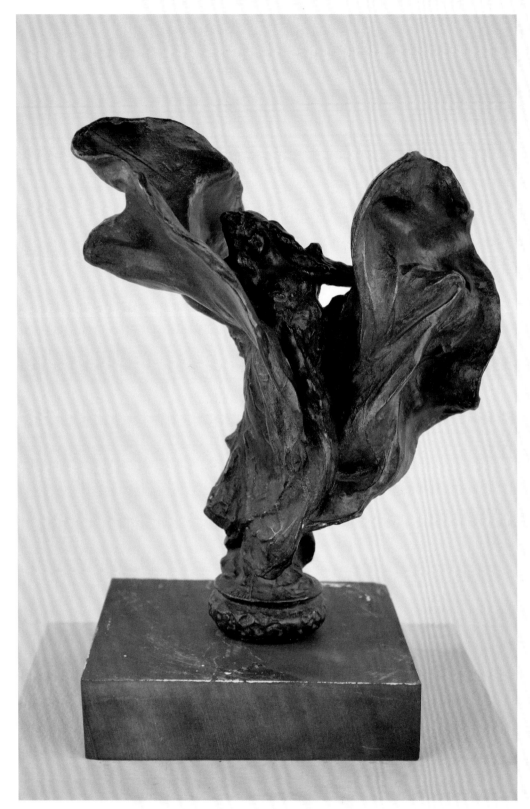

Théodore Rivière
Loïe Fuller dansant
[Loïe Fuller Dancing], n.d.
(cat. 33)

Loïe Fuller dansant
[Loïe Fuller Dancing], n.d.
(cat. 35)

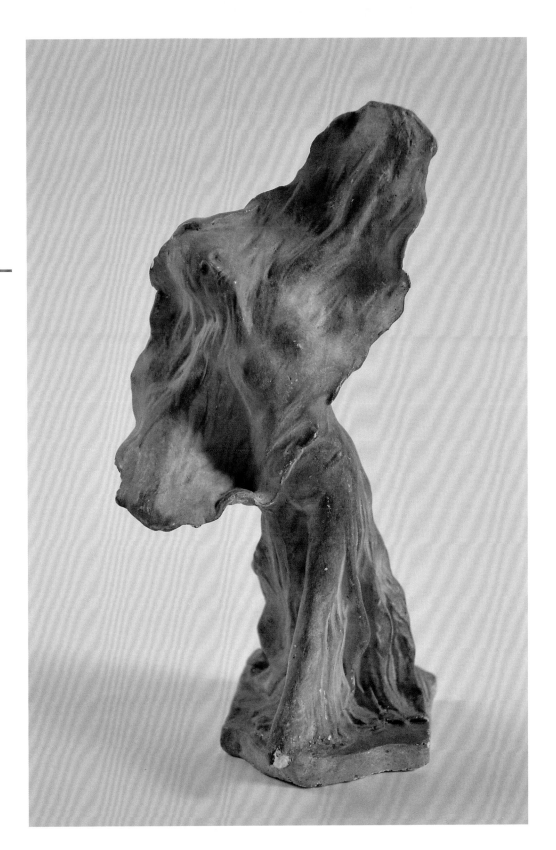

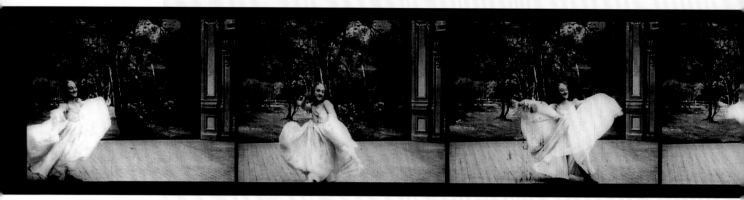

*Parodie d'une danse
de Loïe Fuller* [Parody
of a Loïe Fuller Dance], 1907
(cat. 37)

Danse serpentine
[Serpentine Dance], 1900
(cat. 36)

*Danse serpentine à la manière
de Loïe Fuller* [Serpentine Dance
in the Style of Loïe Fuller], 1900
(cat. 38)

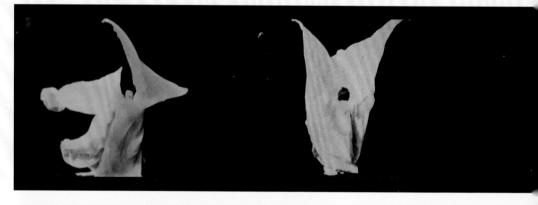

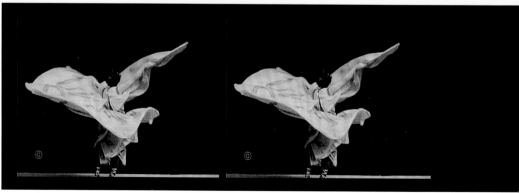

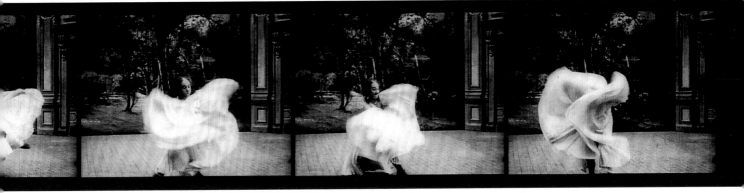

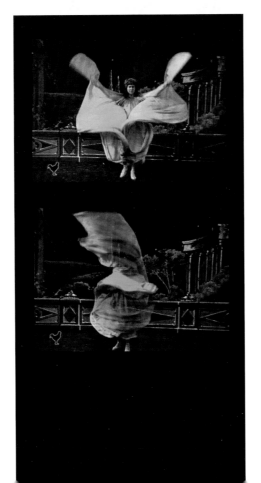

Les Papillons japonais
[The Japanese Butterflies], 1908
(cat. 39)

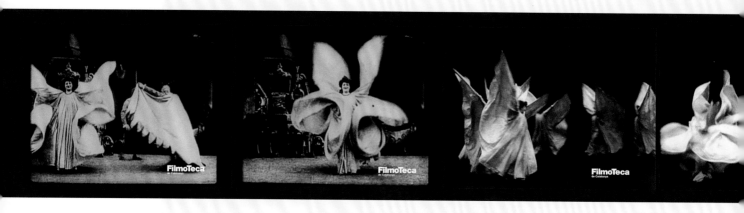

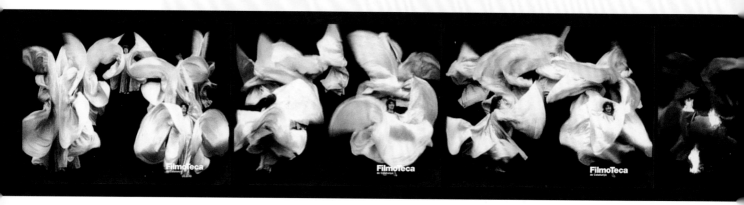

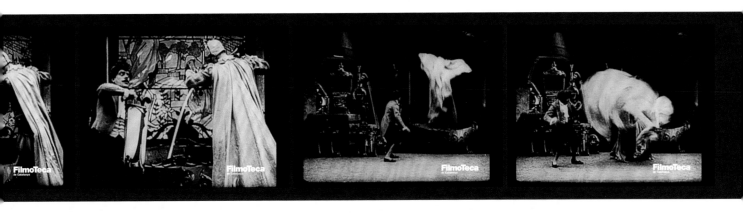

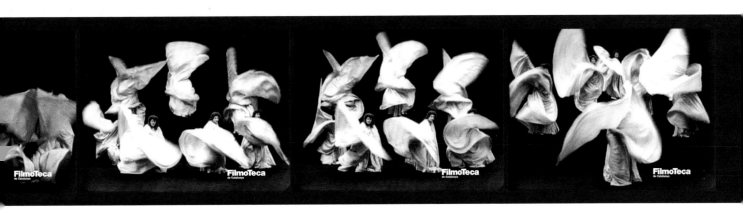

Création de la serpentine
[Creation of the Serpentine
Dance], 1908
(cat. 40)

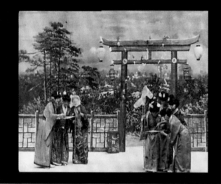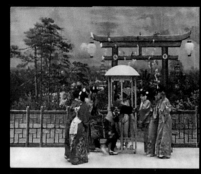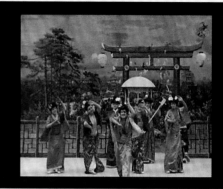

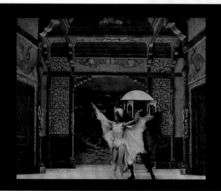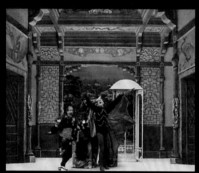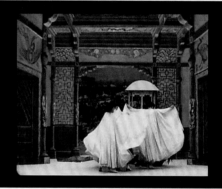

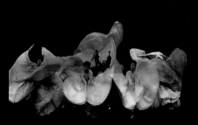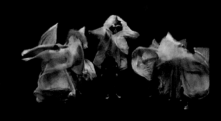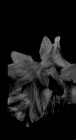

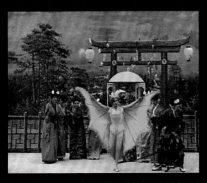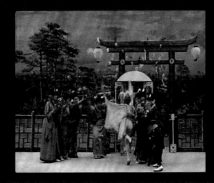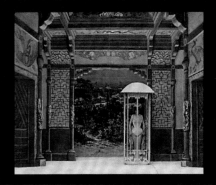

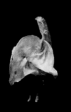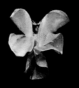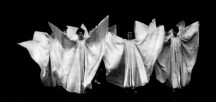

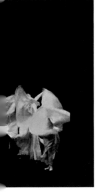

Farfalle [Butterflies], 1907
(cat. 43)

Loïe Fuller and Auguste Rodin: Dancer and Impresario

Hélène Pinet

Early on in her career, in response to press requests and as publicity material, Loïe Fuller sought out photographers from both sides of the Atlantic who could capture the magic of her dance. The Musée Rodin preserves over a hundred photographic images representing her posing or dancing, either alone or with her students. The origins of this collection are to be found in the bonds that the American dancer and the French sculptor first formed in 1898. Fuller seems to have come into Auguste Rodin's life in that year, although it is likely that he had already seen her dance. Certainly he would have heard her described in the most glowing terms by her many friends in the world of journalism and literature, even though her milieu was very different from his. Roger Marx, a great friend of Rodin and one of the first champions of Art Nouveau, wrote that Fuller's success was due to "the contrast between her dances and those previously on offer".[1]

At this period Rodin was a well-known, though certainly controversial, artist. He had just gone through a gruelling time on account of his statue of Balzac, which had provoked a great deal of criticism in the press, both nationally and internationally. Fuller, who had arrived in Paris six years before without speaking a word of French, was no simpleton and knew how to cultivate friendships that would help further her career. Thus, she made connections with famous people, already well established in their fields, who could help her both to perfect her art and to promote it.

In her 1908 autobiography,[2] Fuller allots Rodin only one short chapter, leaving us hungry for more. The numerous letters she sent him never mention her own career and focus especially on Rodin's presence in the United States, dealing principally with problems related to the exhibitions of his work that she organised.[3]

Loïe and Rodin

Fortunately, another person who was close to both artists, Emilia Cimino-Folliero (1854–1944), corresponded with Rodin and proves to be a significant source of information. Cimino-Folliero was a painter, an ardent suffragette, occasionally Rodin's translator and a great admirer of Fuller in spite of some reservations about her attitude towards the great man. She was the one who first described Fuller's personality to him, and she was sharp-eyed enough to see into her motivations:

[1] Roger Marx, "Chorégraphie. Loïe Fuller", *Revue Encyclopédique* (1 February 1893).

[2] Loïe Fuller, *Quinze ans de ma vie* (Paris: Société d'Édition et de Publications, Librairie Félix Juven, 1908), with preface by Anatole France. English ed., *Fifteen Years of a Dancer's Life* (London: H. Jenkins, 1913).

[3] The correspondence preserved by the Musée Rodin numbers 228 documents dated between 1898 and 1917.

Yesterday I saw Loïe Fuller at her home; she was charming and looked ten years younger without that ugly hat that hides her beautiful forehead. I was not mistaken, she is a high-class person.

She will certainly ask you to make a Tanagra figurine, a big one, representing her. And when you have her posing for you, you will like her even more than you did during her visit. . . . She is just as eccentric as she gave the impression of being when she came to visit you, and all the more perfect because of it. . . . She really likes you, and that is what adds even more to her charm.[4]

The relationship between Fuller and Rodin was built on conscious mutual interest. One shared project was to link them a little more closely in 1899. Both were thinking about what they might do for the 1900 World's Fair. Rodin decided to build his own pavilion on the Place de l'Alma, outside the actual exhibition area, as Gustave Courbet had done before him, in 1855 and 1867, and Édouard Manet in 1867. He may in this respect have been the inspiration for Fuller, who had her own pavilion built in record time by the architect Henri Sauvage: covered in white stucco, "imitating a huge veil with plaster folds applied to its swirls",[5] it stood on the left bank of the Seine, across from the one built by Rodin. All the decoration was designed to celebrate her: from the sculptures and stucco work by Pierre Roche to the stained-glass windows by Francis Jourdain, everything, down to the smallest detail, evoked Fuller or her art. The foyer of the pavilion looked like an art gallery where paintings, drawings and sculptures portraying her had been assembled. Rodin was by no means the first artist to enter Fuller's orbit, and her style of dance had caught the eye of many other sculptors before him: Pierre Roche of course, but also François-Rupert Carabin and Théodore Rivière, whose 1898 marble sculpture bore the title of one of her performances: *Danse du Lys* [Lily Dance].

It was not surprising then that by 1900 she was hoping to acquire a work by Rodin to exhibit in her pavilion and add to her collection. She lobbied Cimino-Folliero, who saw Rodin regularly around that time and faithfully conveyed Fuller's messages: "She has often brought up the possibility of posing during the month of June, and wants to have the statue for the exhibition. But I have told her to settle it directly with you."[6]

And in fact, between 1899 and 1901 or thereabouts, Fuller did pose for Rodin, though not on any regular schedule. We also know that Cimino-Folliero took advantage of their sessions in the studio to make some sketches herself. However, given the vague references in the documents, it is difficult to know whether Fuller posed for drawings, a sculpture (which is less likely) or a bust. One critic described the scene:

You may smile at first when entering the Dépôt des Marbres in the Rue de l'Université, where Miss Fuller and Rodin, who is making a statue in her likeness, are conversing—she in a loose white shirt, he in his black waterproof. But your smile very quickly gives way to a more serious and

[4] Letter from Emilia Cimino-Folliero to Rodin, 26 October 1898, archives of the Musée Rodin.
[5] Camille Mauclair, "Sada Yacco et Loïe Fuller", *La Revue Blanche* (15 October 1900).
[6] Letter from Emilia Cimino-Folliero to Rodin, May 1900, archives of the Musée Rodin.

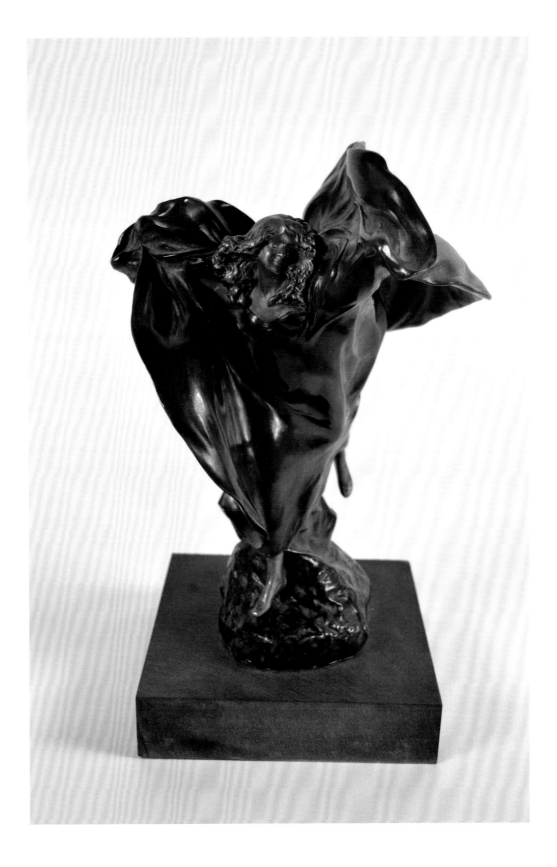

Théodore Rivière
Danse du Lys [Lily
Dance], 1898
(cat. 34)

more just reaction, as you listen to the strenuous debates that go on among the marble and plaster figures, debates in which the dancer holds her ground against the clever, assertive sculptor.[7]

But in spite of all of this, no work by Rodin modelled on Fuller ever saw the light of day. Their correspondence is silent on the subject. It must be acknowledged that Rodin's artistic style was the least well suited to capture the fleeting nature of the rippling forms that Fuller traced in the air. As he once stated, "the sight of human forms nourishes and cheers me". His entire oeuvre is a hymn to the modelling of the human body, while Fuller's whole art lay precisely in making the body dissolve completely into abstract shapes. Even the suggestion that the effects created by the lines of her draperies and the play of her colours might have given him ideas for his drawings, rather than her body giving him ideas for a sculpture, seems an unlikely one. In any event, to this day no example of such a sculpture has come to light.

Loïe regularly visited Rodin's studio, where he held an open house every Saturday afternoon. There she met other artists, such as the painter Eugène Carrière and the critic Camille Mauclair, along with many of Rodin's English and American admirers, including Kate Simpson, Mary Hunter and Alma Spreckels.

But Loïe also had her own famous acquaintances, which she shared with Rodin. In 1902 she brought Pierre and Marie Curie to Meudon, where Rodin had had the exhibition pavilion from the Place de l'Alma reconstructed on the property where he was then living. There he displayed all his plaster casts: this deeply impressed his visitors, who described the place as being like a museum. On another occasion she decided to bring the writer Anatole France and Madame Arman de Caillavet to visit the studio[8]—during this period she was friendly with France, who would write the preface to the French edition of her memoirs.[9]

The diplomatic Fuller knew how to humour Rodin, her prize guest, as well as his inner circle. In a letter informing him of the opening night of one of her performances, Emilia Cimino-Folliero wrote, "Loïe makes her debut tonight at the Olympia at eleven o'clock: she has reserved two boxes for you, and has also invited your friends Mirbeau, Carrière. . . . Druet will be there too".

The people selected to join this soirée are no surprise. Octave Mirbeau, man of letters, author of the *Jardin des supplices* [The Torture Garden, 1899], which Rodin had illustrated, was deeply receptive to the forms of flowers and the emotions they evoked, and must have been completely entranced by the performance of a dancer who was so often compared to a lily or an orchid. Finally, Eugène Carrière, highly esteemed by Rodin, created almost monochrome

[7] Jérôme Doucet, "Miss Loïe Fuller", *La Revue Illustrée* (1 November 1903).
[8] Letter from Loïe Fuller to Rodin, 1907, archives of the Musée Rodin.
[9] Loïe Fuller, *Quinze ans de ma vie*, op. cit. (note 2).

Letter from Loïe Fuller to Auguste Rodin, 1915 (cat. 67)

canvases on which he painted using long undulating strokes very much like those Fuller traced in the air with her veils. Eugène Druet, Rodin's chosen photographer since 1896, readily took pictures of Fuller as well, bringing out some of the verve of her nature. His are the only photographs in which she seems to enjoy showing off her generous body; she poses in a somewhat histrionic fashion on a makeshift pedestal, creating effects with a gossamer veil or with her billowing white dress, which she lifts up to make butterfly wings with the help of perfectly visible long curved rods. It is doubtlessly because Druet was the one who took these photographs that it has been claimed that Fuller danced for Rodin. However, there is no further evidence for this claim.

Perhaps it was to convince Rodin to sculpt or draw her that Loïe gave him a great many photographs of her. The forms outlined by her veils were eminently photogenic: once fixed on paper, they were instantly recognisable by the spellbound audience who saw her appear by turns as a spiral, an orchid, a lily, a tempest, a bird, a bat or a butterfly.

The proliferation of this kind of graphic record bears witness to her success. Fuller used photographic images extensively to advertise herself, in various formats, including visiting cards and large-format photographs. This corpus of photographic documents, through which we can study the evolution of her art, presents an alluring image: a woman with ample curves, leaping into a whirlwind that seems to lift her off the ground, a sort of joyful Bacchante, a woman liberating her body in the élan of the dance. Only the feet and head emerge from the ever-changing, irregular forms produced by this mass of energy.

The Impresario

At some points in her career, Fuller acted as an impresario or agent for other artists, earning commissions on the sales or contracts that she arranged. These activities increased over the years, as she never ceased to face huge financial problems. It was thanks to her that in 1900 Rodin, along with the rest of Paris, discovered the Japanese actress Sada Yacco, who featured in the first part of one of Fuller's shows. The play, *La geisha et le chevalier* [The Geisha

and the Cavalier], was performed in Japanese, but the simple plot and the acting style, very close to mime, meant that the public could easily follow the action. The final scene, in which Sada Yacco commits suicide, deeply touched the audiences of the day, and when a journalist asked Rodin what he thought was the highlight of the World's Fair he replied without a moment's hesitation:

> It was definitely the Far East section that induced in me the most vivid impressions. The staircase from Cambodia and the bas-reliefs from the Sino-Dutch monastery seemed to me art of an extraordinarily high calibre, all hitherto unknown; and then the exotic dances, above all at Loïe Fuller's pavilion, and with her this Sada Yacco, whose art is so alive and absolutely perfect.

It is likely, although impossible to confirm, that Fuller asked Yacco, on behalf of Rodin, if he could sketch her.

Rodin was always intrigued by exotic dance. A few years later, in 1906, he was so impressed by the performance of a group of Cambodian dancers in Paris that he decided to follow them to Marseille, where he once again met with Loïe. She in fact was also to take part in Marseille's Colonial Exhibition along with her new oriental discovery, the Japanese Hanako, for whom she had acted as agent during the last year or so. It was in Marseille that Fuller danced in the open air for the first time, against a background of greenery and fountains. Once again she was an enormous success.

Hanako performed a piece written by Fuller, who had adapted Sada Yacco's closing scene, in which the heroine dies while moaning in the most realistic way. Rodin, once again impressed, asked Hanako to become his model. As a result, the young woman posed on many occasions in his studio, in sessions taking place over several years. The thirty-three studies and masks of her head which he sculpted, and Edward Steichen photographed, were the fruit of this fascination. While she and Loïe soon parted company, Rodin was to remain on friendly terms with Hanako until his death.

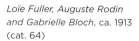

Loïe Fuller, Auguste Rodin and Gabrielle Bloch, ca. 1913 (cat. 64)

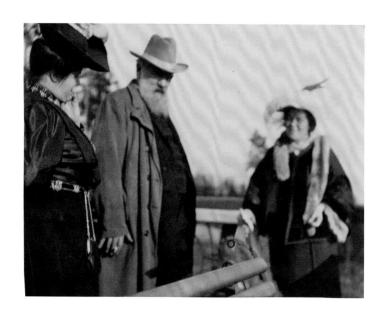

Rodin in the United States

In 1903, in order to diversify her activities and sources of income, Fuller decided to arrange for an exhibition of her—rather mediocre—personal collection at the National Arts Club of New York. The sculptures, drawings and paintings that she asked Rodin to lend her were intended to improve the tone of the event.

Cimino-Folliero, who was in New York at the same time—not to keep an eye on Fuller but to take lessons with the painter Robert Henri, to exhibit her own work and to give a lecture on Rodin at the National Arts Club—is our only source of information. Once she had contacted Fuller in New York, she lost no chance to write to Rodin, who valued her observations, about the installation of the exhibition. Describing Fuller as "a very clever businesswoman", she mentions that she had presented a painting by Georges Rochegrosse as the centrepiece of her exhibition:

> The speculation is because of that. The Rodin pieces are necessary but in smaller numbers, just to attract the attention of the critics. . . . On Thursday evening I insisted we hang your drawings instead of the pictures by the little photographer [Edward Steichen]. This young man had the good taste to want them shown not in Loïe Fuller's collection but with the Rodin works that I had placed next to them. . . . It is difficult to explain to the public how she comes to have such a comprehensive collection of works by Rodin. She loves to pretend you are old and that a senile passion drives you to work night and day for her; she says her plaster casts are those of works that you are sculpting for her in marble, but that she does not want to put pressure on the "poor old man" to complete them because it is well-known that you labour on your projects very slowly.[10]

[10] Letter from Emilia Cimino-Folliero to Rodin, 10 May 1903, archives of the Musée Rodin.

It hardly needs to be said that relations between the two women had deteriorated. Even though Cimino-Folliero's letters sometimes read like a settling of accounts, there is no doubt that they contain more than a grain of truth. In the mentioned letter, she also said that Steichen—a painter

Loïe Fuller and Rodin's
The Kiss, ca. 1916
(cat. 91)

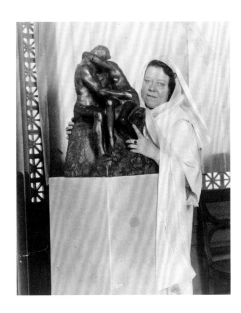

and photographer who was already prominent in the art world—had promised to photograph the works in Fuller's collection to thank her for including his paintings in the show. The collection in question was made up of works "which she has been given by all and sundry". And she added: "Remember, you're just the balloon that she has used to rise off the ground."[11]

From the beginning of this project, Fuller no doubt had the idea of acquiring some sculptures by Rodin and keeping them in the United States—since she had declared them as strictly exhibition items, not to be sold, they were exempted from a sixty percent import duty. But since at this point she could not afford to buy them from Rodin, she used every trick in the book to keep them in New York until she could raise enough money. To win over Rodin, who had been put on his guard by Cimino-Folliero, she found a prestigious site to store them—she asked the curator of the Metropolitan Museum, Frank Edwin Elwell, to store the sculptures for a year—and asked Gabrielle Bloch to take out a mortgage on a property in order to pay the sum of 24,000 francs to Rodin. Actually, the French sculptor was led to believe that his works were on display in the museum until his friend John W. Simpson[12] told him that this was not the case. He then ordered them all to be sent back to France. Fuller tried to get him to change his mind by dangling before him a plan for the funding of his *Tour du Travail* [Tower of Labour] by the banker John Pierpont Morgan, whose portrait Steichen had just painted. She explained that to persuade Morgan she would need to hold on to the plaster model of the monument. However, Rodin, once bitten, was twice shy, and Fuller finally had to send all the pieces back, although she did it in two instalments.

These protracted negotiations resulted in a breakdown of relations which lasted for several years; until their interrupted association was resumed, for no clear reason and as mentioned before, in Marseille in 1906.

In 1914 Fuller tried again to publicise Rodin by arranging to include his works in a massive show of French art in San Francisco under the auspices of art patroness Alma Spreckels. In order to convince Rodin to participate, once again she brought up the project of the *Tour du Travail*, which this time she claimed might be funded by a major show.

The project had originally been instigated in 1899 by Armand Dayot, at that time Inspector of Fine Arts, who wanted to build a tower commemorating labour for the 1900 World's Fair. Rodin had been made responsible for overseeing the creation of the monument, which had been commissioned jointly to several artists. Although he quickly built a scale model, the cost of the monument turned out to be prohibitive and it was never built. Cimino-Folliero, who was very close to Rodin at

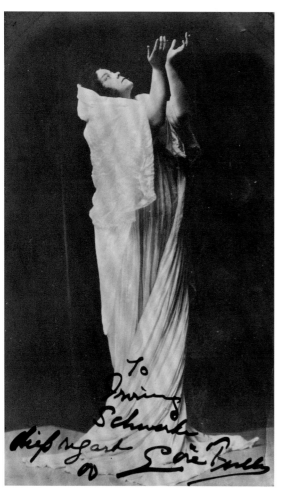

Autographed Photo by Loïe Fuller, n.d.
(cat. 94)

the time, tried to have the famous tower built in England and Fuller apparently took up her idea some years later, though with no better success.

Nevertheless, Loïe lavished optimistic predictions on Rodin, assuring him that Alma Spreckels would fund the tower, "because she loves you, and she loves me, and no one can love me if I don't make her understand your art". The argument, written in rather elementary French, was as simple as it was effective. Fuller thus sailed for San Francisco to organise the exhibition, just at the point when war broke out. Once in the United States, she expressed great anxiety about the fate of her French friends and tried to persuade Rodin and Camille Flammarion to move to America.

At the same time as the exhibition project, she and Armand Dayot organised a sale of works of art, also in San Francisco, in benefit of the war-wounded. She collected ten thousand books by Pierre Loti, D'Annunzio, Maeterlinck and Maspero, among others—three hundred of them autographed—as well as about one hundred engravings and abundant signed photographs, mostly by Rodin.

As a result of Fuller's efforts, Rodin, who at this point had travelled from London to Rome, was bombarded with letters asking him to exhibit in the United States, including lists of specific works to be shown. Unable to deal by himself with the mound of requests, he asked Fuller to come back to meet with him, although, to avoid future problems, he made her sign a great quantity of official documents listing the works she had permission to send to the United States, broken down into those paid for, not paid for, finished or still in progress.

Despite Rodin's misgivings, the Panama-Pacific International Exhibition did indeed take place. Alma Spreckels immediately bought four sculptures from him, and over the next few years acquired thirty-six of his bronzes, fifty-three plaster casts, five marble sculptures and nine drawings for the San Francisco Palace of the Legion of Honour, devoted to French art, which was completed in 1924.

The dissemination of Rodin's work in the United States thus owes a very great deal to the energy and enthusiasm of Loïe Fuller.

[11] Ibid.
[12] In 1902 Rodin had sculpted a bust of his wife Kate.

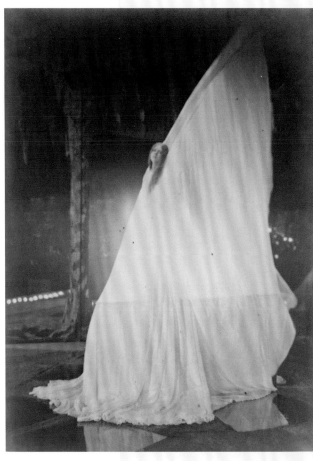

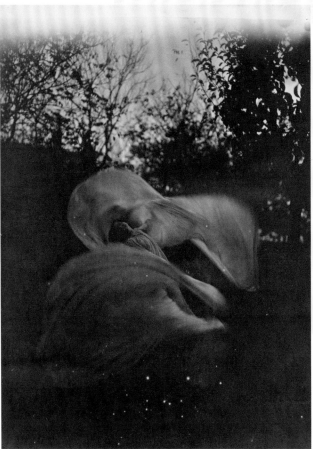

Eugène Druet
*Loïe Fuller in Costume for
the Archangel Dance*, 1901
(cat. 46)

Eugène Druet
Loïe Fuller Dancing, n.d.
(cat. 58)

Eugène Druet
*Loïe Fuller Posing on a Table
for the Archangel Dance*, 1901
(cat. 50)

Eugène Druet
*Loïe Fuller Posing on a Table
for the Archangel Dance*, 1901
(cat. 51)

Eugène Druet
*Loïe Fuller Posing on a Table
for the Archangel Dance*, 1901
(cat. 54)

Eugène Druet
*Loïe Fuller Posing on a Table
for the Archangel Dance*, 1901
(cat. 53)

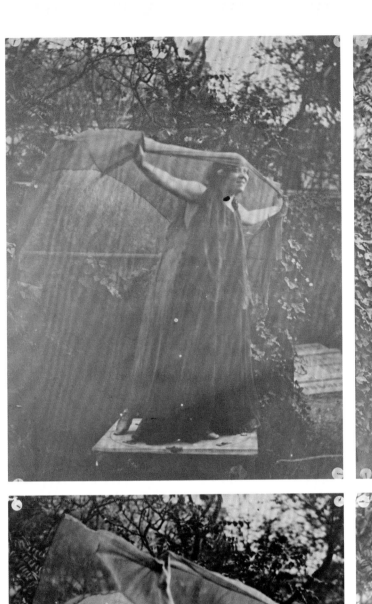
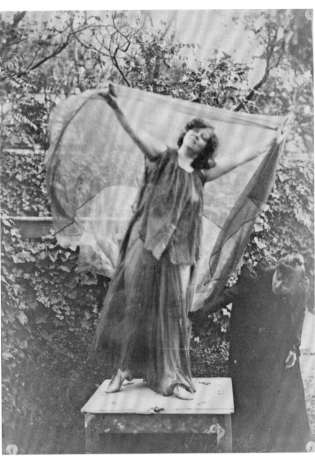
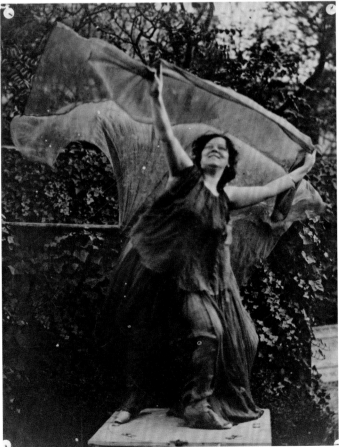
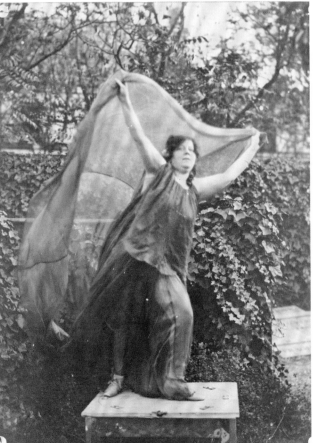

Loïe Fuller
L'Oiseau noir [The Black Bird], n.d.
(cat. 44)

Loïe Fuller
Notes for an Essay on Dance, n.d.
(cat. 45)

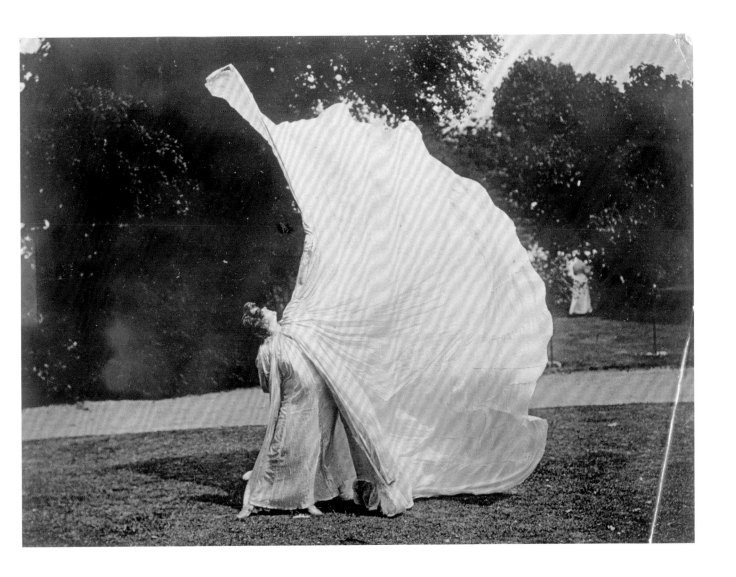

Harry C. Ellis (attributed)
*Loïe Fuller Dancing
in a Park*, 1909–1914
(cat. 47)

Eugène Druet
Loïe Fuller Dancing, 1900
(cat. 49)

Eugène Druet
Loïe Fuller Dancing, 1900
(cat. 52)

Loïe Fuller
Danse ultra violette
[Ultraviolet Dance], n.d.
(cat. 55)

Langfier
*Delilah Fuller, Loïe Fuller
and Mr. & Mrs. Flammarion*, n.d.
(cat. 60)

L'Hippodrome.
Le Petit Orchestre, 1907
(cat. 56)

*Letter from Camille Flammarion
to Loïe Fuller*, 1915
(cat. 61)

Gabrielle Flammarion
*Flammarion Home and
Observatory*, 1927
(cat. 62)

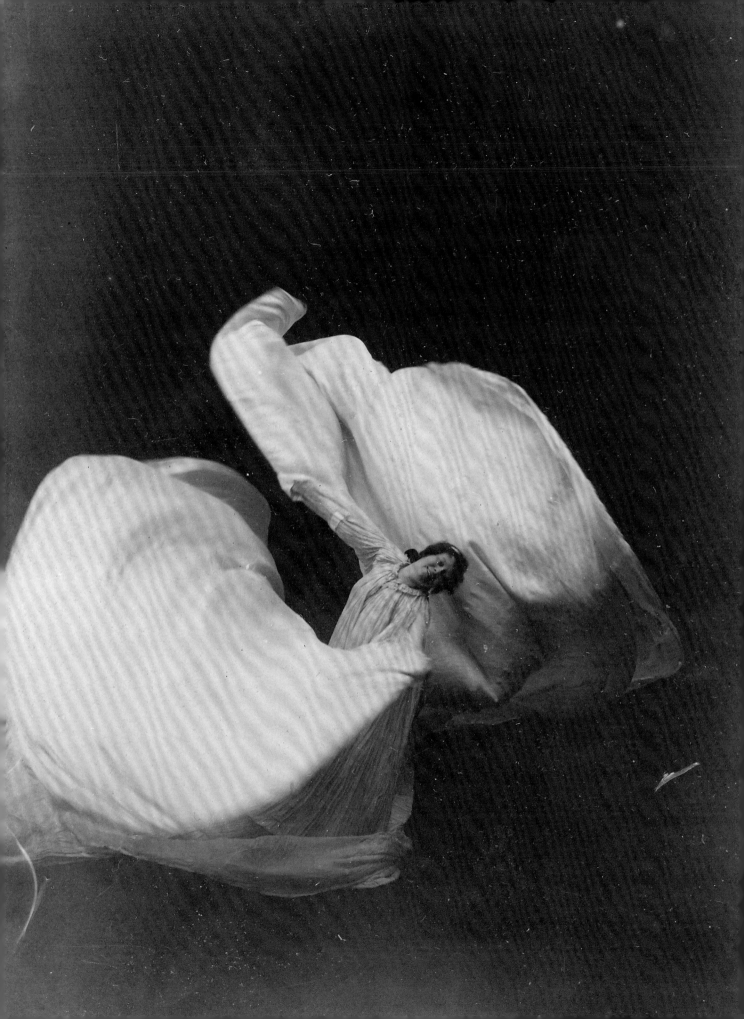

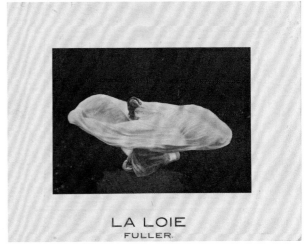

Isaiah West Taber
Loïe Fuller Dancing, ca. 1900
(cat. 66)

Dance of the Eyes, ca. 1907
(cat. 68)

Loïe Fuller Dancing, ca. 1905
(cat. 70)

Loïe Fuller, n.d.
(cat. 69)

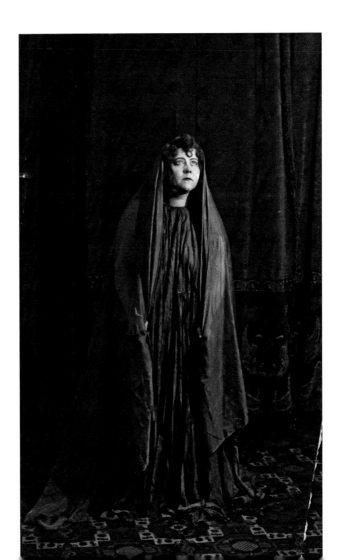

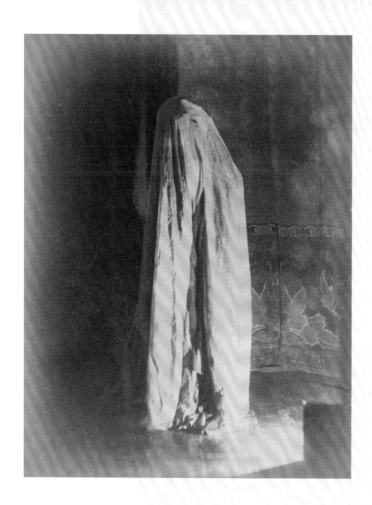

R. Moreau (attributed)
Loïe Fuller with Veil, 1900
(cat. 71)

Loïe Fuller
Autobiography, n.d.
(cat. 72)

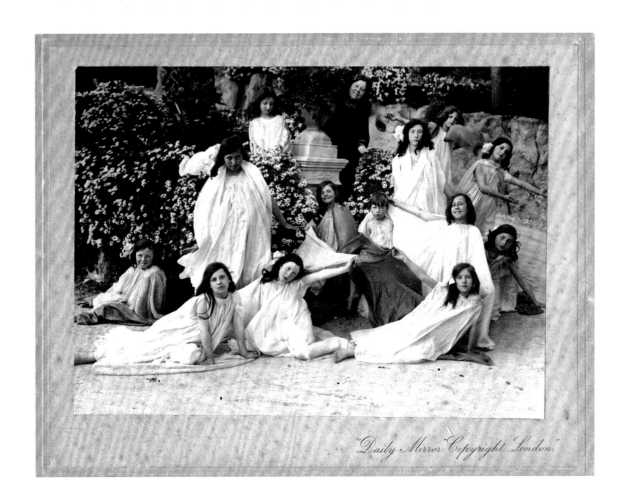

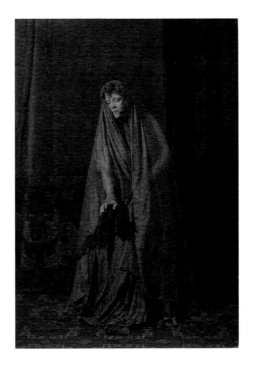

Loïe Fuller with Students, ca. 1908
(cat. 73)

R. Moreau
Loïe Fuller, n.d.
(cat. 74)

Loïe Fuller: Dance as Science

José Manuel Sánchez Ron

Dance, the art form practised by Loïe Fuller, is motion but it is also colour and light, which are essentially physical phenomena. Scientific knowledge is not, of course, a prerequisite for mastering the art of dance; nevertheless, Loïe Fuller did strive to acquire at least some of that knowledge, which made her a rare bird in the dance world. Her efforts were actually quite successful, allowing her to amass an admirable wealth of scientific knowledge as a largely self-taught scholar, although she did benefit from her friendship with several eminent scientists (and we must not forget that when she became a star at the Folies Bergère in Paris in the early 1890s, the director provided her with every technical resource she required, enabling her to experiment and perfect her performances). Her love and respect for science were unmistakable, as evidenced by the words she wrote on a rough draft for her "Lecture on Radium" included in a notebook compiled between 1907 and 1911, now held in the Jerome Robbins Dance Division at the New York Public Library:

> Science is—as we all know—the uncovering of facts in Nature.
>
> As Nature discloses her truths to us, it opens the doors of understanding and reason!
>
> Those things which are looked upon as unreal—supernatural—are—one by one—proving to be the results of natural causes, all part and parcel of this world and its products, the most advanced "unreal" fact being the telegraph without wires.
>
> On reflection these things bring us face to face with the greatest result of all progress, the end of superstition.

Motion, Light and Colour

Logically, it is always difficult to pinpoint the origin of intellectual achievements or ideas, and Loïe Fuller's interest in science is no exception. However, she did leave us several clues in her

1908 autobiography, entitled *Quinze ans de ma vie* (published in English as *Fifteen Years of a Dancer's Life* in 1913). On the subject of her role in the play *Quack Medical Doctor* in 1891, which led to one of her most famous creations, the serpentine dance, she wrote:

> I obtained a spiral effect by holding my arms aloft while I kept whirling, to right and then to left, and I continued this movement until the spiral design was established. Head, hands and feet followed the evolutions of the body and the robe. . . . I studied each of my characteristic motions, and at last had twelve of them. I classified them as dance no. 1, no. 2, and so on. The first was to be given under a blue light, the second under red light, the third under a yellow light. For the illumination of my dances I intended to have a lantern with coloured glass in front of the lens. I wanted to dance the last one in total darkness with a single ray of yellow light crossing the stage. . . . I am astounded when I see the relations that form and colour assume. The scientific admixture of chemically composed colours, heretofore unknown, fills me with admiration, and I stand before them like a miner who has discovered a vein of gold, and who completely forgets himself as he contemplates the wealth of the world before him.

In other words, she found that dance—or organised motion—colour and light were all closely connected. Thus, the butterflies, orchids and clouds that Loïe's dances suggested, with her long robes of weightless fabric, took on a new dimension. The *Danse du feu* [Dance of Fire] she created in 1895, which was a great success at the Folies Bergère, is a splendid demonstration of her ideas and experiments. In this piece, light shone up through a glass-covered hole in the stage floor above which stood a hollow base covered with mirrors for directing the light, while the rest of the stage, draped in black, remained in total darkness. Thus, when she danced on the glass cover, Fuller resembled a ghostly apparition floating in the air, and when she used the coloured lights, ranging from yellow to bright red, her silhouette embodied the very essence of fire.

Although Chapter 6 of *Quinze ans de ma vie* does not specify when it occurred, another special moment that reinforced Fuller's ideas about the role of the science of light and colour in the visual arts was her first visit to the Cathedral of Notre-Dame in Paris. Prior to that moment, she was struck by the fact that in the museums she had visited, such as the British Museum and the National Gallery in London and the Louvre in Paris,

> the architects have not given adequate attention to considerations of light. As a result of this defect I get in most museums an impression of a disagreeable medley. When I look at the objects for some moments the sensation of weariness overcomes me, it becomes impossible to separate the things from one another. I have always

wondered if a day will not come when this problem of lighting will be better solved. The question of illumination, of reflection, of rays of light falling upon objects, is so essential that I cannot understand why so little importance has been attached to it. Never have I seen a museum where the lighting was perfect. . . . The efforts of the architect ought to be directed altogether in that direction—to the redistribution of light. There are a thousand ways of distributing it.

Moving onto a purely scientific plane, Fuller continues:

Colour is disintegrated light. The rays of light, disintegrated by vibrations, touch one object and another, and this disintegration, photographed in the retina, is always chemically the result of changes in matter and in beams of light. Each one of these effects is designated under the name of colour. . . . Man, past master of the musical realm, is to-day still in the infancy of art, from the standpoint of control of light.

If I have been the first to employ coloured light, I deserve no special praise for that. I cannot explain the circumstance; I do not know how I do it. . . . It is a matter of intuition, of instinct.

And a few paragraphs later, she adds:

How often we have heard it said: "I cannot bear this colour." But have we ever reflected that a given motion is produced by such and such music? . . . In the quiet atmosphere of a conservatory with green glass, our actions are different from those in a compartment with red or blue glass. But usually we pay no attention to this relationship of actions and their causes. . . .

Light, colour, motion and music.

Observation, intuition, and finally comprehension.

In *Quinze ans de ma vie*, Fuller also recalls the time she was taken by Countess Wolska to call upon a distinguished scientist, the astronomer Camille Flammarion (1842–1925), who helped her develop her ideas about the effects of colour. Flammarion, Loïe explained, was "not content with being an eminent astronomer. He counts among his assets some discoveries of the greatest interest, most of which have no relation to astronomy". One of the things that interested Flammarion was to "know whether colour has a certain influence on organisms", and

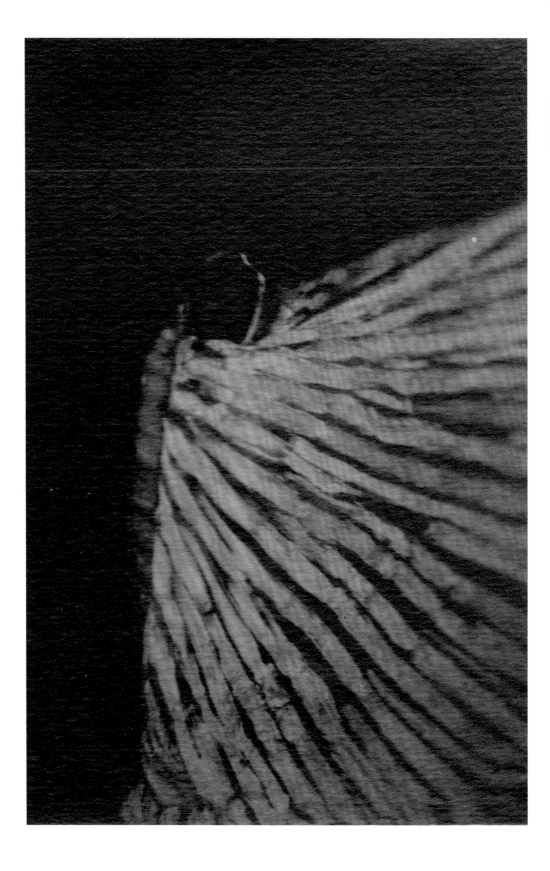

Loïe Fuller, 1893
(cat. 17)

to answer this question he began experimenting on plants, and later on people, using different-coloured panes of glass in the windows of his observatory. Fuller asked him if he thought that "the colours with which we are surrounded have an effect on our characters", to which the astronomer and popular scientist replied, "There is no doubt".

Loïe Fuller and Thomas Edison

Another turning point in Fuller's scientific learning process came in 1896, when she visited Thomas Alva Edison's (1847–1931) famous laboratory in Menlo Park, New Jersey. There, the brilliant inventor showed her a fluoroscope, an early version of an X-ray machine (the radiation discovered by Wilhelm Röntgen in 1895) that produced phosphorescence, a phenomenon whereby certain substances become luminous when they receive energy (such as sunlight). When Edison placed Fuller's hand inside the machine, the flesh turned translucent, rendering her bones visible. "Mr. Edison explained to me", Loïe wrote in the manuscript for a lecture delivered in 1911 ("Prelude to Light"), "that the wall in the box [the fluoroscope] was covered with phosphorescent salts and these salts compressed the light as sand did water and that was why one could see the bones". The explanation was incorrect, but we must remember that at this point scientists did not yet understand the role of phosphorescence in X-ray technology, nor had they grasped the nature of the new radiation (this would be discovered in 1912 thanks to the ideas of German physicist Max von Laue). Shortly after Röntgen made his discovery, Edison invented a device, the aforementioned fluoroscope, hoping to use this new technology for commercial purposes. The machine he showed Fuller was undoubtedly closely related to the experiment performed by Röntgen in 1895, when the German physicist discovered that if a certain type of radiation (X-rays) generated using a cathode ray tube was directed at a screen painted with barium platinocyanide, the surface would become fluorescent (a more permanent type of phosphorescence). Barium platinocyanide is a salt, and this may be the "salt" that Fuller mentions, although it also could have been calcium wolframate, as Edison discovered that plates coated with this substance yielded brighter images (X-rays).

In the same lecture text quoted above, Fuller continued, "It suddenly occurred to me that if I could have a dress permeated with that substance it would be wonderful. I asked Mr. Edison if the salts would retain the luminousness once the lamp was gone. He hadn't thought of that so we tried it and lo and behold the light remained". However, there was one major problem: upon experimentation, she found that fabrics permeated with those salts did in fact become phosphorescent, but they also became too stiff to use in her aerial sculpting technique.

From X-rays to Radioactivity: Loïe Fuller and the Curies

The link between X-rays and phosphorescence/fluorescence led to the idea that phosphorescent substances might give off X-rays. Among these substances were uranium salts, which the physicist Henri Becquerel (1852–1908) had in stock at his laboratory in the Musée national d'Histoire naturelle in Paris. However, what Becquerel ultimately discovered in March

1896 was that the uranium contained in those salts gave off a new and different type of radiation that was every bit as mysterious as X-rays. This was "radioactivity", a term coined by Marie (1867–1934) and Pierre Curie (1859–1906) in 1898, the same year they discovered two new radioactive chemical elements that were much more powerful than uranium: polonium and radium.

Although no one understood how a chemical element could emit radiation (in other words, energy) in a seemingly constant and continuous manner, radioactivity soon became widely popular in scientific circles (Becquerel and Marie and Pierre Curie were jointly awarded the Nobel Prize for Physics in 1903), as well as in other fields, especially medicine (where the use of X-ray technology had quickly become firmly entrenched). The theory was that the powerful effect of the radiation emitted by radioactive substances could be used to destroy tumours. The market was soon flooded with books that discussed the medical and therapeutic properties of radium, the most powerful radioactive element. These publications documented an extensive series of treatments and case studies in which radium was used to treat ailments such as neuralgia, gonorrhoeal rheumatism, tuberculosis of the glands, lymphoma, rheumatoid arthritis, corneal ulcers and catarrhal illnesses. The treatment consisted in applying substances that contained radium to areas with malignant or benign tumours in order to shrink or eliminate them. The idea of radium as a panacea for virtually every ailment remained popular throughout the first three decades of the 20th century. A number of miracle products were developed, such as face creams containing radium that promised to rejuvenate the skin, or radium baths to recover the energy and vigour of youth.

In the midst of such widespread excitement, it is no wonder that Loïe Fuller took an interest in radioactivity. One of the things that sparked this interest was the World's Fair held in Paris from April to November 1900, whose eighty-three thousand exhibitors drew over forty-eight million visitors. In the most heavily frequented pavilion, the Palace of Electricity, fitted with five thousand multi-coloured incandescent light bulbs and a series of dynamos that supplied electrical power for the entire fair, visitors were able to see a demonstration of how radium emitted light. The World's Fair was instrumental in publicising radium, as we can deduce from the fact that a collection of fifty postcards released under the title *En l'an 2000* [In the Year 2000] and sold as souvenirs during the World's Fair included one devoted to this new radioactive element. The "Chauffage au radium" [Radium Heating] postcard showed a living room scene with four people gathered around a fireplace that contained radium instead of logs.

Loïe Fuller
Notebook with Draft of a "Lecture on Radium", 1907–1911
(cat. 57)

Page 11:

the subject of my phosphorescence up again.

This distinguished professor was 75 years of age, and I was astonished when I found he took a deep interest in it.

This distinguished professor took a deep interest in it and we went to work, this time in his laboratory. Before long we had a few grammes of sulphur of calcium, sulphur of zinc, sulphur of some thing producing violet, green, yellow & red. I was in ecstasy. The next thing to do was to find the way to apply it to silk, & here we encountered our greatest stumbling block — the liquid gum melted the powder before we could get it stuck onto the silk. And when this was accomplished, half the powder was lost. This was serious, especially so far as sulphur of zinc was concerned for it cost us something like £120 the ounce. Half a pound — & we required at least 6 lb for the dress I wanted.

Page 12:

when we had accomplished the application of the salts to the silk, it was like a board! nothing could be done with it. If we made a dress I couldn't even get it on! —

It was, to say the least, very discouraging — not to mention all the money spent, & we had been working over two years.

At last necessity the mother of invention filled the place that science couldn't find. —

I observed that a scarf we were experimenting with, which had only patches of salts on it — because all illuminated in movement, when it was in the dark when it was in motion. So it occurred to me to put the powder on in stripes — and by gumming the dress first — and then sprinkling the powder on it, we lost but a small percentage. And in consequence of the stripes the goods would fall in pleats. — providing thus

Page 13:

providing us with the suppleness, which we had tried so long to find, — by thinning the gum and substance that neither were any good.

Then we took a great dress of 100 yards and began our work all over again. — For this dress we permitted with used sulphur of calcium — and used over six pounds, of which we made about 24 grammes a day. —

Although the wonderful green of sulphur of zinc was astonishingly beautiful, the sulphur of calcium dress — so like the light of the moon was exquisite & much very very much less expensive than the zinc. =

Then we made a dress or a veil out of black gauze and spotted it with the calcium,

When the veil was thrown up into the air, it disappeared

Page 14:

in the darkness and only the falling luminous drops were seen elongated in their descent taking on the form of a great white blue tears. — The dress in movement produced the same effect, and I was told that I seemed to far back & away from the falling tears, the black gauze of the dress being invisible, & I myself seemed to be a black silhouette of figure. =

We made huge green & gold butterflies, with red spots on their backs. And green serpents —

These things looked ethereal, spiritual & made one feel in touch with the supernatural.

We took the big dress to Sarah Bernhardt — enormous theatre, & when it was all in motion it lighted the auditorium up so that you could read in farthest corner

Page 17:

light compared to a great search light. —

So my dance of tears, butterflies of green ghost of serpents, & the great silver moon have never been seen. —

I had used the phosphorescence but a reason — to express something, when as those that were shown to the public by enterprising managers were Punch but travesties & harlequinades not festivals all hard & thick stuck all over with luminous paint — for no other reason than to show off the paint. —

So my dance of tears, spirit butterflies, ghosts of green serpents — & the silver moonlight — have

Page 18:

never been seen, and I am here telling you about them instead of how they led me into the land of Radium. — Because it was through this that I met Madame Curie. but I did not study with her, not until standing a statement which has been made to that effect. — I would be proud to have done so, but the statement is not true. many of the few things I know about Radium however due to my acquaintance with that gifted woman & about whom I may perhaps say this much: No woman has ever lived whose unpretentiousness & simplicity are so remarkable. no success, no adulation, no fortune could be great enough to tempt her from her simple path — or spoil her. —

Just like another illustrious visitor to the Paris World's Fair, the American writer and historian Henry Adams (1838–1918), who recorded his impressions of the event in a chapter of his book *The Education of Henry Adams* entitled "The Dynamo and the Virgin", Loïe Fuller, one of the stars of the fair (the architect Henri Sauvage designed a theatre specifically for her to dance in), was awestruck by radium. In her particular case, it inspired a desire to create "butterfly wings of radium". Her idea was to use radium to make wings that glowed in the dark, an idea that would, in fact, soon be put into practice in other fields. For example, radium was mixed with paint to create luminous displays on watches, clocks and other instruments. The technique, first developed in Germany in 1908, was as follows: crystals of zinc sulphide were mixed with radium salts, and the alpha particles (nuclei of helium atoms) emitted by the salts in their radioactive decay collided with the molecules of the zinc sulphide crystals, creating a luminous glow that made it possible to "see in the dark".

Fuller soon contacted the Curies to ask them about her idea of creating radium butterfly wings. They replied that it would be impossible, as they only had access to a minuscule amount of radium, but their correspondence soon blossomed into friendship. In addition to giving private dance performances for the Curies, Loïe helped them to fulfil one of their dearest wishes: meeting the great sculptor Auguste Rodin. On 16 April 1902, Fuller sent Rodin the following telegram: "May I bring Monsieur and Madame Curie of radium, who have asked me to introduce you to them, to Meudon tomorrow Sunday, after midday?"

In Chapter 11 of *Quinze ans de ma vie*, the great artist of dance describes their visit:

[The Curies] had never been at Meudon before, and they were not acquainted with Rodin. They were just as simple as the master himself. When I introduced them not a word passed. They grasped each others' hands, and looked at each other. Then, when we left, they grasped each others' hands again, and held them for some little time. That was all. Yet, no, that was not all. In the looks they exchanged there was a world of intelligence, appreciation, comprehension. . . . The former [Pierre], brown, tall and thin, the latter [Marie], slight and blonde, had alike a single aim, that of not making themselves conspicuous.

The visitors remained at Rodin's mansion, "Les Diamants", for two hours. As they drove away in the carriage, Loïe asked the Curies to describe their impressions, but her efforts were in vain. However, it is interesting to read how the dancer describes them: "These two people are known throughout the world. They are the greatest chemists of our day, peers of the celebrated Berthelot. Since then the husband, like Berthelot, has gone to his last rest and the wife carries on their common activities."

Loïe's interest in radioactivity reveals that she was anything but a dilettante. We find ample proof of this in the cramped and often illegible handwriting of the twenty-five-page notes for her abovementioned "Lecture on Radium". For example, she was well aware of how difficult it had been for the Curies to isolate polonium and radium:

> The discovery of radium was not—as discoveries usually are—the result of an accident, but it was an accident, in so much as it was an unexpected result of a long and tedious chemical research on the part of Mr. and Mrs. Curie, the final result having been found by Madame Curie herself. It was the result of separating and reducing matter to the smallest possible quantity.

The notebook also refers extensively to the work of William Crookes (1832–1919).

> Prof. Crookes, the eminent English scientist, has discovered something through the use of radium of very great interest and of still greater importance. He has found that radium can so illuminate certain substances that with the aid of a magnifying glass it can be seen that atoms are in reality not atoms at all, but intense, concentrated energy.

She was almost certainly referring to a fairly obscure theory that Crookes—as well as Russian chemist Dmitri Mendeleev (1834–1907), creator of the periodic table of elements—posited around 1898. This theory held that ether, which many believed to be the matter that filled outer space at the time, created "centres of attraction" that could be likened to "atoms"; and radium and polonium, as chemical elements with a very high atomic weight, should therefore be able to generate such "atomic centres". Loïe was more explicit in her mention of an important device that Crookes invented in 1903, the spinthariscope. This was the first instrument that made it possible to observe the sparks created when alpha particles emitted by a radioactive element collided with a fluorescent screen.

Ultraviolet Dance

Loïe Fuller's relationship with the Curies was not limited to radioactivity or even to Pierre and Marie: in 1925 she introduced Marie to the composer Gabriel Pierné so that he could assess the musical aptitude of her daughter Ève (1904–2007). But this fact, though certainly interesting—as was Ève Curie's entire life, during which she became a concert pianist and war correspondent—has little bearing on our present discussion. On the other hand, it is pertinent to mention a visit that Fuller paid to Pierre Curie's lab at the École Municipale de Physique et de Chimie Industrielles, shortly before the scientist was struck and killed by a horse-drawn carriage on 19 April 1906. Fuller described the experience in a text published as an appendix to a new edition of *Quinze ans de ma vie*, re-released under the title *Ma vie et la danse* [My Life and Dance] in 2002. The visit inspired her to create a new dance, which she christened "ultraviolet dance" in honour of the electromagnetic radiation whose wavelength ranges from approximately 400 nanometres ($4 \cdot 10^7$ metres) to 15 nanometres ($1.5 \cdot 10^8$ metres): in other words, a light beyond the colour violet, the shortest wavelength the human eye can perceive.

In his lab, Pierre showed her "the light called ultraviolet", a ray invisible to the naked eye yet emitted by a 60-ampere projector operating on a 220-volt system. "All this radiation is invisible until an object is placed in its path, which is then wonderfully illuminated." After making a few more comments, Loïe wrote,

> In order to give me a demonstration of radiation and the importance of "ultraviolet" light beams, Professor Curie placed a transparent glass filled with water in the rays' path; both glass and water were illuminated with a dark blue light. He then proceeded to drop a few specks of dust into the water, which drifted slowly to the bottom of the glass without mixing. It was then I observed not only that these specks of dust remained intact but also that, despite being illuminated, the light was not, as one might have expected, violet in hue.

Loïe was "very impressed" by the experiment, which led her to wonder if she "could transfer the wonderful effects of that dust [to a dress] to show them to the world". She asked Pierre Curie for some of the dust, and he obliged. "To describe the laborious work that followed, in which I was aided by the wisest chemists of our time, would be a dull undertaking. Suffice it to say that I was successful." Yet her success was not complete, as she admitted that the fabric of her garments "remained impervious to any ray of light", with the exception of a scarf "that changed from one colour to another under ultraviolet light". "For this reason", she concluded, "although my robes never actually turn violet, I call this dance 'the ultraviolet dance'".

The techniques involved in Loïe Fuller's ultraviolet dance and the very idea of this kind of artistic performance have endured to the present day, in the context of what is now called

Ève Curie, n.d. (cat. 77)

"black theatre" or "black light theatre". Thus, like the memory of her efforts to insert science in dance, and by extension in the stage design of theatre performances, Loïe Fuller is still present among us. Far from representing a minor chapter in the history of the performing arts, her achievements are an admirable example of imagination, effort and innovation that we must never forget.

Bibliography

Blanc, Karin, ed., *Pierre Curie. Correspondances* (Saint-Rémy-en-l'Eau: Éditions Monelle Haycot, 2009).

Current, Richard Nelson, and Marcia Ewing Current, *Loïe Fuller. Goddess of Light* (Boston: Northeastern University Press, 1997).

Fuller, Loïe, *Quinze ans de ma vie* (Paris: Société d'Édition et de Publications, Librairie Félix Juven, 1908). English ed., *Fifteen Years of a Dancer's Life* (London: H. Jenkins, 1913).

Fuller, Loïe, *Ma vie et la danse. Suivie de écrits sur la danse* (Paris: Éditions l'œil d'or, 2002).

Garelick, Rhonda K., *Electric Salome. Loïe Fuller's Performance of Modernism* (Princeton, New Jersey: Princeton University Press, 2007).

Loïe Fuller
Notes on Ève Curie, n.d.
(cat. 76)

*Letters from Marie Curie
to Loïe Fuller*, 1924
(cat. 78)

Students of Loïe Fuller, n.d.
(cat. 75)

Harry C. Ellis
*Loïe Fuller Dancing in
Her Paris Studio*, ca. 1914
(cat. 79)

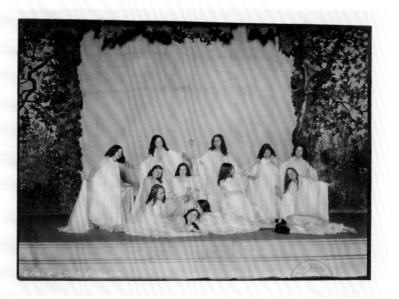

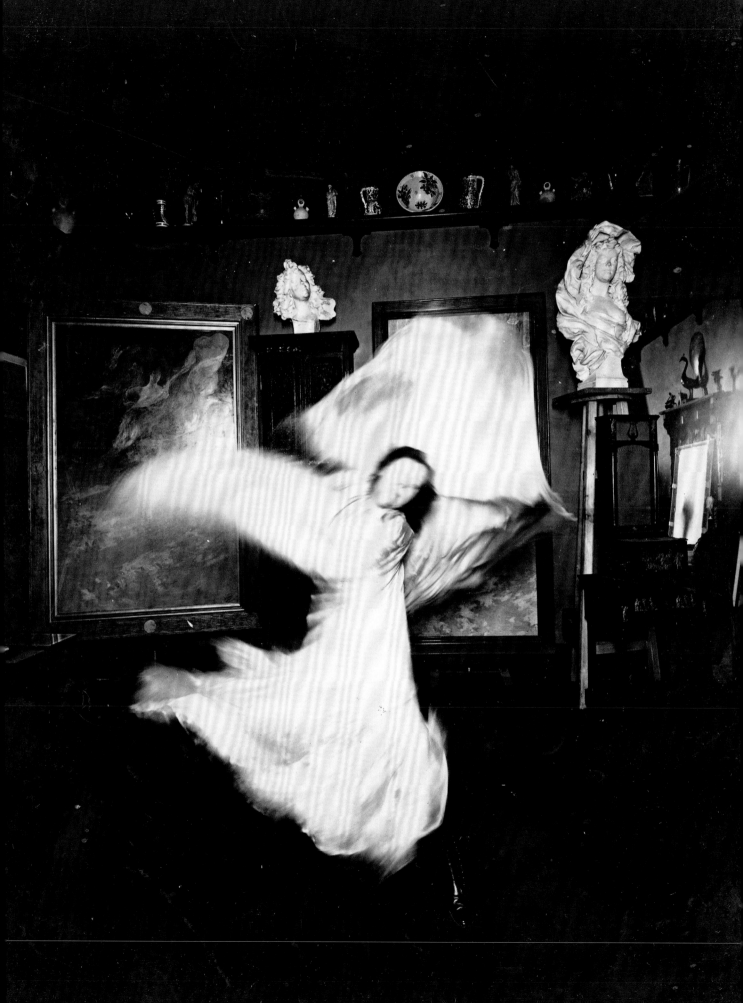

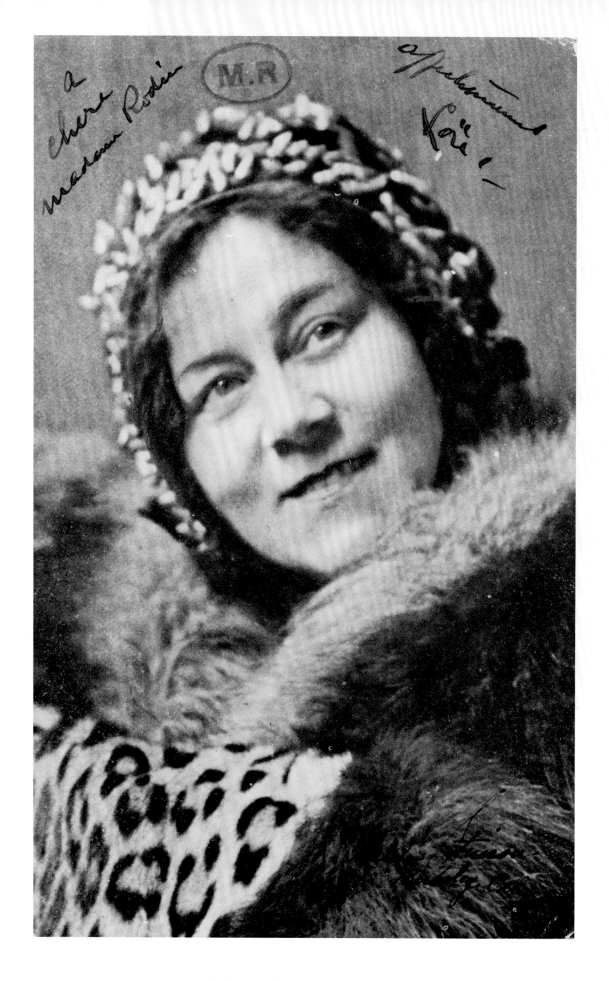

Portrait of Loïe Fuller, ca. 1914
(cat. 80)

*Letter from Loïe Fuller to
Gabrielle Bloch*, n.d.
(cat. 81)

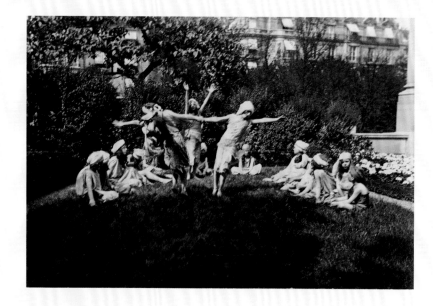

Harry C. Ellis
Students of Loïe Fuller Dancing,
1914
(cat. 82)

Harry C. Ellis
Students of Loïe Fuller Dancing,
1914
(cat. 83)

Harry C. Ellis
Students of Loïe Fuller, 1914
(cat. 84)

Harry C. Ellis
*The Muses Performing in Camille
Flammarion's Garden at Juvisy*,
n.d.
(cat. 85)

*Loïe Fuller and Her Muses
Performing* A Night on Mont
Chauve *at San Francisco's
Festival Hall*, 1915
(cat. 86)

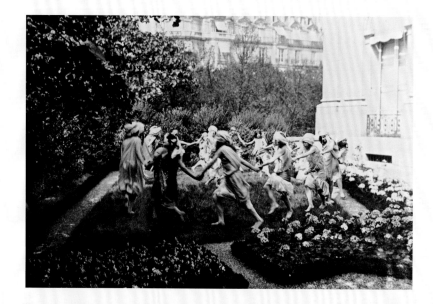

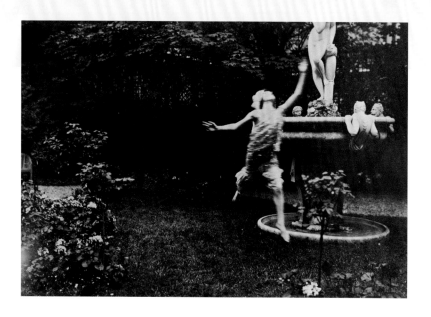

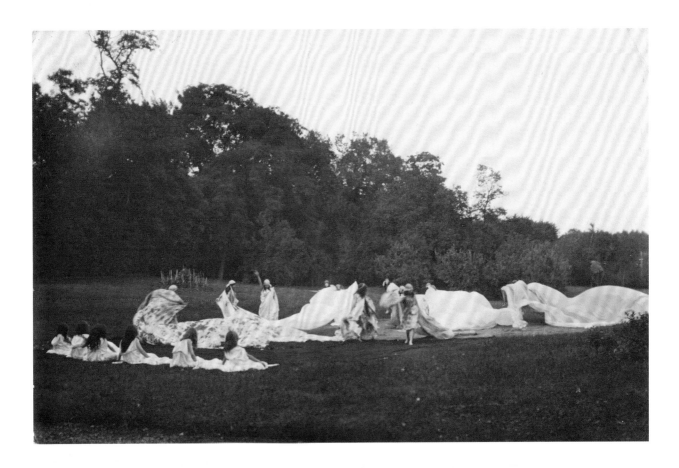

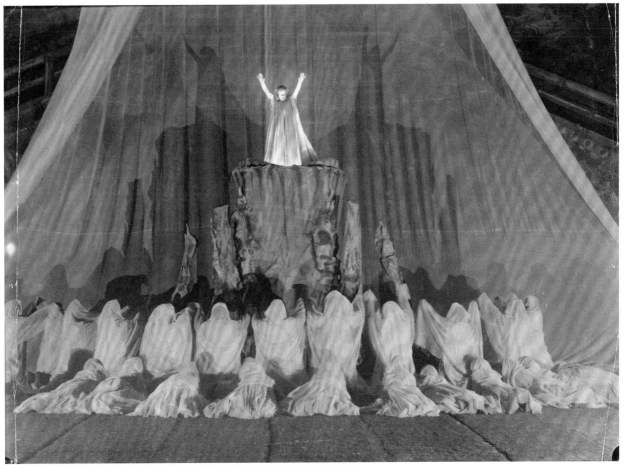

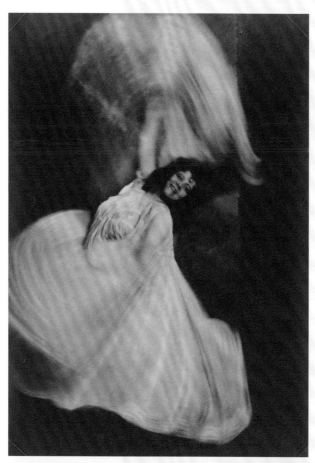

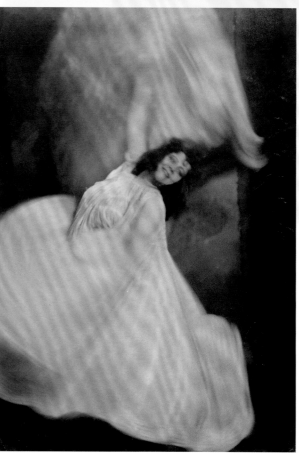

R. Moreau
Loïe Fuller Dancing, n.d.
(cat. 89)

Eugène Druet
*Loïe Fuller Performing the
Archangel Dance*, 1901
(cat. 88)

*Letter from Alma Spreckels
to Loïe Fuller*, 1914
(cat. 90)

La représentation du 26 février dernier, au Stadium d'Athènes, devant le Roi et la Reine de Grèce.

Loïe Fuller et son École de Danse [Loïe Fuller and Her Dance School], 1914 (cat. 92)

Harry C. Ellis *Loïe Fuller Posing during Her Show*, 1914 (cat. 93)

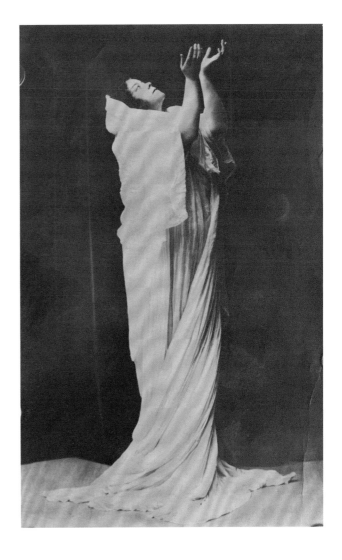

Living Fluxes: Insects and Metamorphosis in Science, Culture and the Popular Imagination

Santos Casado

Throughout Western history, sages, scholars and individuals we now call scientists have reacted to living things in two opposite ways, if we can accept such a vague and necessarily incomplete dichotomy. The first reaction has been to acknowledge and wonder at the ability of living things to remain stable in their forms, to reproduce them with such marvellous accuracy from parents to children, to multiply them in thousands of identical subunits, like leaves on a tree or scales on a reptile, and to restore them by regeneration or healing where inanimate objects that suffered a similar fate would be helpless to reverse the alteration or wear. On the other hand, some have been fascinated by the fluid generative capacity of the living, by that mysterious power to change shape while preserving identity, by the almost infinite possibilities open to beings capable of autopoiesis, growth, adaptation or metamorphosis.

This second perspective, which views life as a flowing, changing, adaptable force, naturally prevailed over the first in the cultural context of the late 19th and early 20th centuries. For proof we need look no further than to modern art's fascination with the exuberant proliferation of organic forms, typically incorporated in the most familiar ornamental expressions of Art Nouveau. However, this was no mere artistic or cultural trend, nor a faddish fashion. The vitalist probing of the turn of the century, the interest in the driving forces behind life, was the expression of a mentality that took the Western world by storm and was intertwined with the very science of nature, as it was understood and developed in those transitional decades.

In physics, the fascination with radioactivity—discussed elsewhere in this volume—led to a new conception of the properties of matter that was more receptive towards mutability and latency. In medicine, the workings of the human brain and how the properties of psychic life emerged from it became the focus of active investigation and heated debate. In biology, an interest in observing the habits, relationships and transformations of living beings, retrieved from the annals of traditional natural history, began to sprout up left and right, and the idea of life as a dynamic flux was reinforced while the overly rigid, static biological systems developed in the 18th century to comprehend and classify organisms were rejected.

One vital phenomenon synthesised life's fascinating ability to redefine itself better than any other: metamorphosis, in particular the metamorphosis of insects. And, more particularly still, the cyclical morphological adventure of the transformation from caterpillar to pupa to butterfly and back to the caterpillar again.

Entomological Amusements

The connection between the naturalist observations of insect life cycles and the creation of a cultural imaginary around metamorphosis—an imaginary which in time would spread far and wide, even among the working classes—the connection, as I was saying, was primarily established through artistic productions related to natural history: the plates, watercolours and prints that proliferated in the 18th and 19th centuries, fixing a clear iconographic reference that would later be revised in the fin de siècle period. Although I have noted that the 18th century was a time of system and classification for the field we now call biology, it also provided an outlet for that other school of naturalism which focused more on the dynamic expression of living phenomena. In this regard, we would be remiss if we did not acknowledge the singular contribution of Maria Sibylla Merian's splendid plates, published in the early-18th century, to inspiring a cultural fascination with metamorphosis.

Merian, a German-born painter of flowers and insects, jumped at the chance she was offered in 1699 to travel to the Dutch colony of Suriname, where she remained for two years. There she captured the exotic lushness of tropical flora and fauna in an eloquent series of images that, after being engraved, were used to illustrate her book *Metamorphosis insectorum surinamensium* [Metamorphosis of the Insects of Suriname], published in Amsterdam in 1705. The very title under which the painter chose to publish her work made it clear that this entire gallery of new life forms revolved around the metamorphosis of insects, whose stages were depicted on each plate alongside related plants. Merian's entomological scenes thus offered European readers a dynamic and sometimes near-riotous vision of the drama of life, depicted both collectively—as creatures that live and interact together, even when that interaction entails devouring each other—and individually, in her painstakingly detailed illustrations of the metamorphic cycle of caterpillars, pupae and butterflies.[1]

But Merian was not the only one. Other illustrated volumes were released in this century, such as the entomological treatises of the German August Johann Rösel von Rosenhof, filled with tinted engravings that depicted the stages and forms of insects—especially butterflies—in their cycles of metamorphosis. Rösel von Rosenhof had read Merian's book and was deeply

[1] See Kay Etheridge, "Maria Sibylla Merian and the Metamorphosis of Natural History", *Endeavour*, vol. XXXV, no. 1 (March 2011), pp. 16–22.

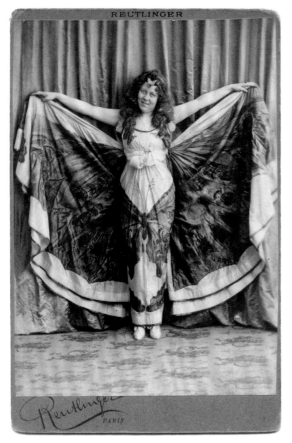

Reutlinger (Paris)
Loïe Fuller, 1893
(cat. 9)

impressed by it. That influence is obvious in the way he designed and organised his own plates, in this case dedicated to European insects. Many were quite common, but in this new light they suddenly seemed full of dynamic energy and vitality. The first of his *Insecten-Belustigung*, or "insect amusements", was released in 1740, and all of them were later compiled into three volumes published in Nuremberg in 1746, 1749 and 1755.[2]

But Rösel von Rosenhof's engravings, while admirable for their naturalistic detail and wealth of entomological information, lacked the vibrant vivacity of Merian's painted scenes, where larvae and adults mingled in an acknowledged biological anachronism, climbing or fluttering about their host plants. In contrast, in Rösel von Rosenhof's later plates the successive stages of each insect are neatly arranged from top to bottom and left to right in a clear reading order that indicates the chronological sequence of the depicted insect's life cycle. This orderly, analytical, carefully systematised presentation was a reflection of the classificatory, encyclopaedic spirit of reason that marked his century.

Not until the mid-19th century would a renewed interest in studying the nature of nature itself—in studying "live" life, if you will—once again fill the pages and plates of natural history books with a more dynamic, even theatrical vision of the vital fluxes of insects and many other living creatures.

[2] Partially republished in August Johann Rösel von Rosenhof, *Insecten-Belustigung* (Dortmund: Harenberg, 1979).

Reutlinger (Paris)
Loïe Fuller in Costume for the Butterfly Dance, 1895 (cat. 6)

Reutlinger (Paris)
Loïe Fuller in Costume for the Butterfly Dance, ca. 1893 (cat. 7)

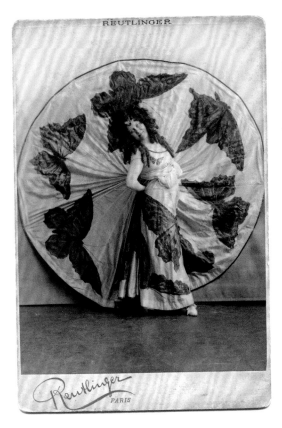
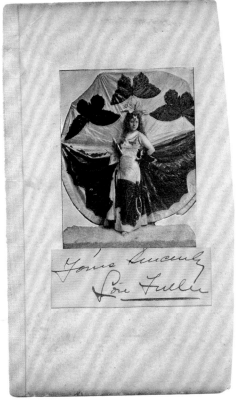

Small Tales

The development of a new scientific approach to ecology over the course of the 19th century ran parallel to the emergence of science-related art forms, expressed as illustrations of a technical or popular nature with more than a few hybrid or intermediate variations. These consisted of engravings and plates included in treatises or manuals, illustrated books for dissemination or education, wall sketches for teaching purposes and a variety of other visually striking formats. Thus, the static, isolated depiction of living things gave way to a riotous world of animated scenes of animals in their natural habitats, pictures that showed the interaction between different species or dramatic illustrations infused with vital energy in which organisms were represented hunting or being hunted, caring for their young or going through one of the astounding processes of metamorphosis.

This was the golden age of popular science gurus like the Frenchman Jean-Henri Fabre,[3] who was to entomology what his compatriot Camille Flammarion was to the study of earthly and heavenly physics.[4] Small tales of animals, particularly insects, filled the pages of books and the imaginations of both the erudite and the common folk. A new sensibility, latent in the modernist, vitalist literature of the turn of the century, was highly receptive to these stories of our diminutive fellow creatures' endeavours and adventures in life. Writers like Edmond Rostand and Maurice Maeterlinck were fascinated by Fabre's entomological narratives. In the case of Maeterlinck, a Belgian who won the Nobel Prize for Literature in 1911, we must not forget that his own literary output included titles such as *The Life of the Bee*, first published in 1901, and the later works *The Life of Termites* and *The Life of the Ant*.

The same phenomenon was apparent in the most popular forms of literature, information and journalism of the turn of the century. In Spain, we find more than a few highly illuminating examples of that renewed interest in the lives of the apparently vulgar beings which surround us—lives that vied to capture the public's imagination by crafting the cleverest tales of exotic creatures and portents with varying degrees of factuality and legend.

The zoologist Ángel Cabrera, a noted scientist and one of the best exponents of popular science in Spain in the early years of the 20th century,[5] made the metamorphosis of a fairly common moth the central theme of a short story in his children's book *Narraciones zoológicas* [Zoological Narratives], published in Barcelona in 1909.[6] In the tale entitled "La mariposa del aligustre" [The Privet Hawk-Moth], Cabrera narrated the life cycle of a nocturnal moth based on a personal experience which he claimed to have had—a claim that seems quite plausible—when he was a boy or a teenager. The entire story takes place in his own backyard, where observation and patience are the only tools that the main character/narrator uses to gradually reveal the fascinating cycle of transformation whereby an egg laid on a leaf becomes a beautiful adult moth, passing through the caterpillar and pupa stages. Although the concept of this book, intended for schoolchildren, may strike us as unoriginal, the freshness of the first-hand narrative—suggesting that the reader, too, can experience direct contact with nature—and the simple way in which wondrous magic is revealed through a humble insect discovered in the author's backyard make "La mariposa del aligustre" particularly effective as a

[3] See Yves Cambefort, *L'œuvre de Jean-Henri Fabre* (Paris: Éditions Delagrave, 1999).
[4] See A. Duplay, "La vie de Camille Flammarion", *L'Astronomie*, no. 89 (December 1975), pp. 405–419.
[5] See Alfredo Baratas and Santos Casado, "El divulgador Ángel Cabrera", in Helena de Felipe, Leoncio López-Ocón and Manuela Marín, eds., *Ángel Cabrera. Ciencia y proyecto colonial en Marruecos* (Madrid: Consejo Superior de Investigaciones Científicas, 2004), pp. 199–214.
[6] See Santos Casado, *La escritura de la naturaleza. Antología de naturalistas españoles, 1868–1936* (Madrid: Caja Madrid, 2001).

Maria Sibylla Merian
(1647–1717)
*Branch of Swamp
Immortelle with
Giant Silk Moths,
Caterpillars and
Chrysalises*,
ca. 1701–1705
Watercolour and
bodycolour over
lightly etched
outlines on vellum,
14 ¹/₁₀ x 11 ¹/₅"
(Royal Collection
Trust/© Her Majesty
Queen Elizabeth II
2014)

 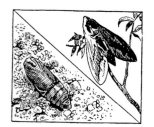

Ángel Cabrera
La mariposa del aligustre
[The Privet Hawk-Moth]
Engravings of original drawings
by Ángel Cabrera published in
Ángel Cabrera, *Narraciones
zoológicas* (Barcelona: Hijos
de Paluzíe, 1909)

motivational tool. Moreover, Cabrera, who was also a skilled draughtsman, illustrated each part of the tale with expressive sketches drawn by his own hand.[7]

That visual aspect was undoubtedly important. The engraving and reproduction techniques developed in the 19th century allowed for a much larger, cross-class market for all types of images. Chromolithography, for example, had made it cheaper to produce colour reproductions. This gave rise to formats intended for new audiences, including children, such as trade cards. One of the most popular editions of this type in Spain during the first third of the 20th century was the promotional collection *Mi álbum "Nestlé"* [My "Nestlé" Album], which included—and this is no coincidence—an entire series dedicated to "Caterpillars and Butterflies".[8]

In a similar manner, photography opened up new possibilities of visual veracity and accuracy in the field of scientific illustration. Entomological pictures, intended to display forms, stages and relationships, could now be carefully staged using real specimens. Resorting once again to a Spanish example of the time, the Spanish Committee for Forest Fauna released a half-technical, half-educational publication in which species of moths and butterflies that affected trees were illustrated with photographic reproductions of entomological displays prepared specifically for the project, showing caterpillars, pupae and adults arranged around their host plants.[9]

As noted at the beginning of this essay, a new way of practising biology did indeed take root, in both the academic and non-academic worlds, during the turn of the century. It was based on a return to the heart of the matter, on reviving the notion of life as an intricate, pulsating flux which decades and even centuries of analytical, systematic studies

Display of
Lymantria Dispar,
or "Gypsy Moth",
Showing the Insect's
Different Stages
on Quercus Ilex
Photographic
illustration published
in Manuel Aulló y
Costilla, *Comisión
de la Fauna Forestal
Española (creada
por R. O. de 17
de Julio de 1913).
Reseñas de los
trabajos verificados
durante los años
1914 a 1916* (Madrid:
Cuerpo Nacional
de Ingenieros de
Montes, 1918)

seemed to have overlooked, focusing solely on anatomic or taxonomic questions. Historian Lynn K. Nyhart, who has analysed that period of German biology, calls this "the biological perspective", in which understanding an organism's place in nature requires attention to its place in "a web of functional and physical relationships", as well as to the "living organism in its natural setting".[10]

Science, which might have posed a threat to the visibility of life, burying it beneath a cold analytical gaze, instead offered new and thrilling perspectives from which to explore the mysteries of its constant metamorphosis—perspectives which, under the cultural influence of the modernising, vitalist, inquisitive spirit of the turn of the century, resonated with the sensibilities of more than a few scientists, writers and artists.

[7] Ángel Cabrera Latorre, *Narraciones zoológicas* (Barcelona: Hijos de Paluzíe, 1909).

[8] *Mi álbum "Nestlé"*, collectible trade card album (Barcelona: Sociedad Nestlé, 1932), series 51.

[9] See Manuel Aulló y Costilla, *Comisión de la Fauna Forestal Española (creada por R. O. de 17 de Julio de 1913). Reseñas de los trabajos verificados durante los años 1914 a 1916* (Madrid: Cuerpo Nacional de Ingenieros de Montes, 1918).

[10] Lynn K. Nyhart, *Modern Nature. The Rise of the Biological Perspective in Germany* (Chicago: University of Chicago Press, 2009), p. 23.

Cola bifurcada [Forked Tail] Trade card for *Mi álbum "Nestlé"*, collectible trade card album (Barcelona: Sociedad Nestlé, 1932), series 51, no. 12

to the enemy when our last
ball has been fired . ---- that
is how we feel .

And into this hour of darkness
came your message of light - of
hope -

Humbly I accepted it as once
the Virgin accepted to message of the
Holy Ghost - for the moment I can-
not believe it - must not believe it
quite - yet I know that my soul
believes it because it is the soul
of a child. "

One more thing : if I should disap-
pear before the great blessing
reaches my hands

let it be given over to the King
and I would design two men I
trust in to be responsible for the gift,
two men I trust in, two men who
have shown that they are of the true
metal - two who would carry on my
work - I shall write their names
down upon a paper and give them
to the little messenger who has
come to me in your name. Perhaps
I shall go to see my sister at Petro-
grad, then we might meet there &
if you have the courage you would
both come one and see with your
own eyes the infinite blessing you
are bringing, a debt that no grate-

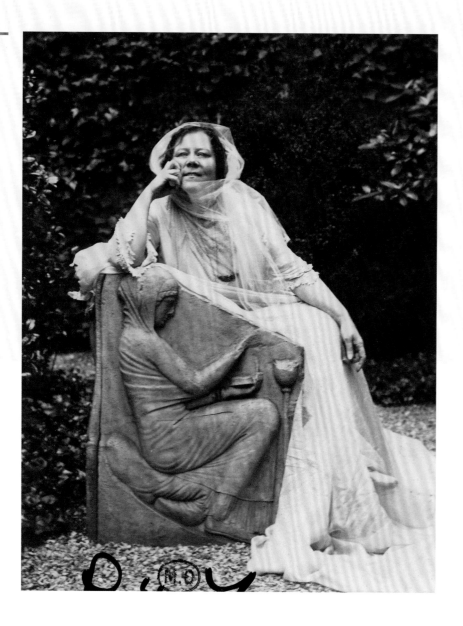

*Letter from Queen Marie of
Romania to Loïe Fuller*, 1917
(cat. 95)

*Letter from Loïe Fuller to
Queen Marie of Romania*, n.d.
(cat. 96)

Harry C. Ellis
Loïe Fuller Seated on a Throne,
1914
(cat. 98)

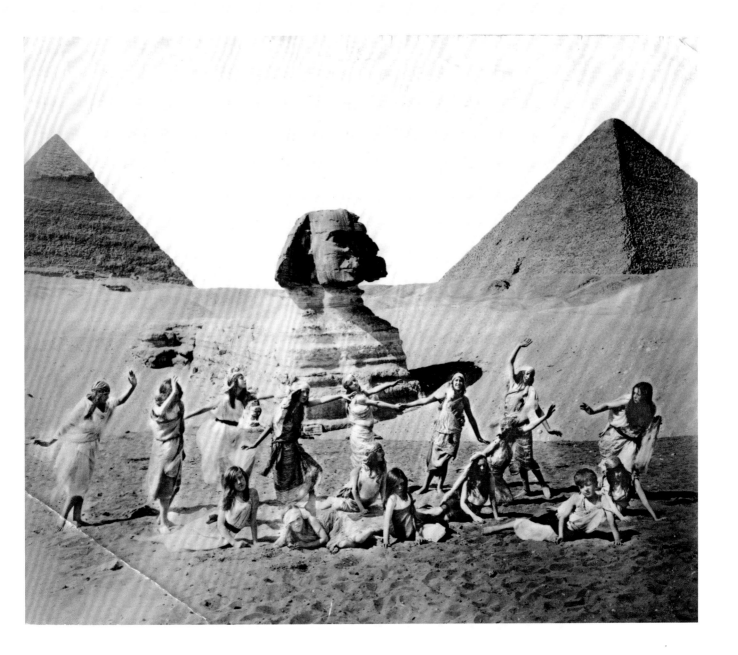

Students of Loïe Fuller in Egypt,
1914
(cat. 100)

*Letter from Queen Marie of
Romania to Loïe Fuller*, 1922
(cat. 97)

Loïe Fuller's Passport, 1923
(cat. 99)

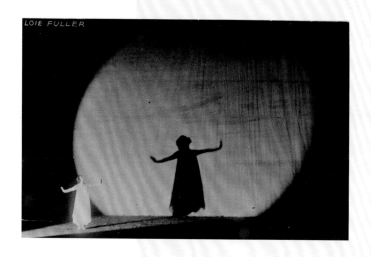

Student of Loïe Fuller
Performing Prometheus, n.d.
(cat. 101)

Henri Manuel
Loïe Fuller, n.d.
(cat. 102)

Harry C. Ellis
Loïe Fuller Recovering
in the Hospital, ca. 1925
(cat. 104)

Harry C. Ellis
En double expression
[Double Expression], 1925
(cat. 105)

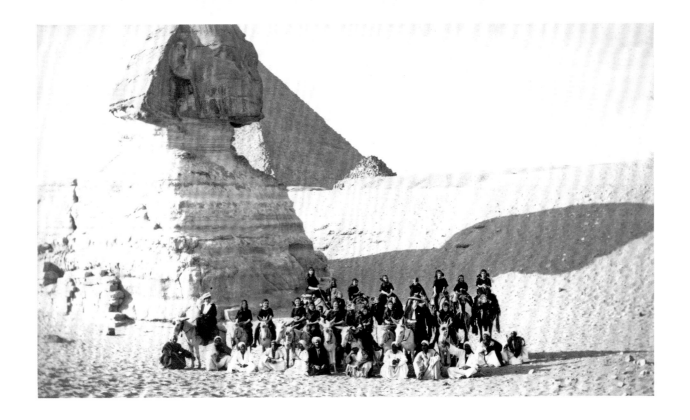

*Loïe Fuller and Her Students
in Egypt*, 1914
(cat. 106)

Loïe Fuller. The Sphinx-Egypt, 1914
(cat. 111)

*Letter from Samuel Hill
to Loïe Fuller*, 1927
(cat. 108)

*Loïe Fuller, Queen Marie and
Princess Ileana of Romania*, 1925
(cat. 107)

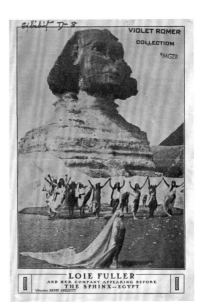

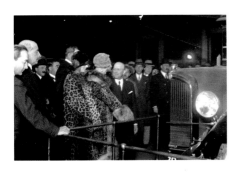

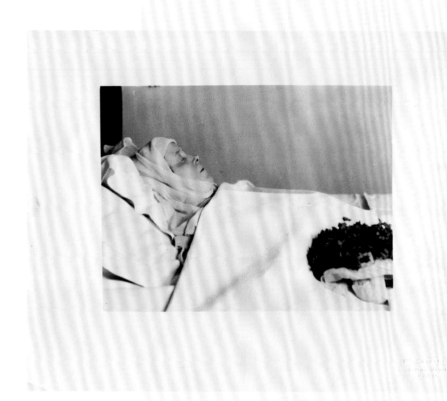

P. Delbo
Loïe Fuller on Her Deathbed, 1928
(cat. 109)

Le Lys [The Lily], 1934
(cat. 110)

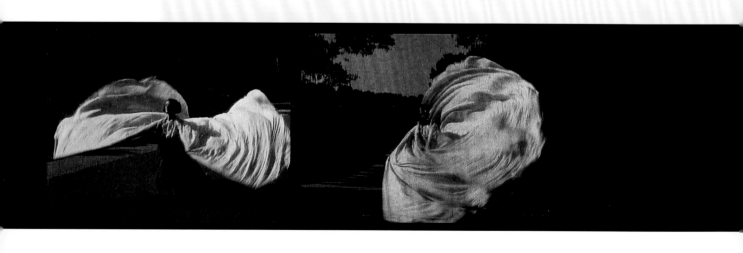

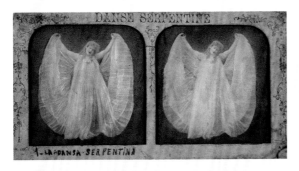

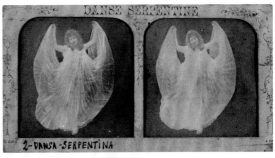

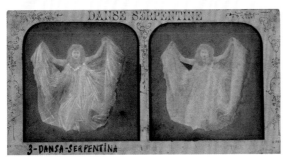

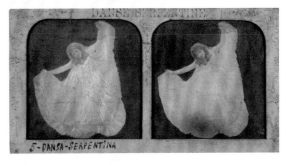

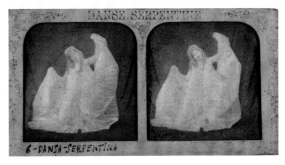

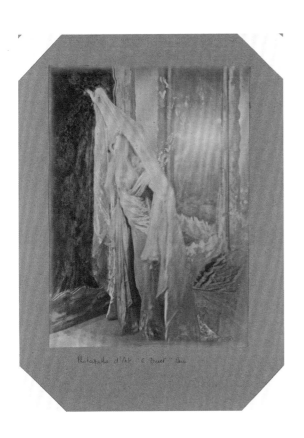

Stereoscopic photographs, n.d.
(cat. 113)

Eugène Druet
Loïe Fuller on Stage, n.d.
(cat. 112)

Hybrid Bodies, Technological Bodies, Natural Bodies. Loïe Fuller-Isadora Duncan: Notes and Reflections on a Field

Simón Pérez Wilson

The body-dance-technology-nature relationship has been in constant tension from the late-19th century to the present day. In that relationship we can identify a variety of conceptual fields, diverse historical and contextual processes that help to explain the fascinating theory and history of dance. Within this referential framework, the 20th century can be seen as a complex, hybrid, decisive moment in the history of art and, of course, in the history of dance. Ideas about what constitutes modern dance first started to emerge in the effervescent years of the turn of the century; when we speak of the pioneers of modern dance we venture into uncharted territory, an experimental space, a place where there are no clear labels as of yet, only ambiguity and hybrids. That is precisely the focus of this text: establishing, conceptualising, contextualising and analytically differentiating where and in what circumstances figures of the stature of Loïe Fuller and Isadora Duncan converge and diverge. Isadora Duncan is indisputably regarded as a seminal figure in modern dance, but can we say the same of Loïe Fuller? Do we really know that much about her and her relationship with Duncan? Exploring the convergent and divergent paths travelled by these two women leads us to contemplate and reflect on the corporealities of dance, the metaphors they evoke, the ideas about art that underpin them. But above all, and in a more complex way, we are compelled to consider the two directions that appeared and were pursued over the course of the 20th and early-21st centuries, which I will loosely call naturalism and technologisation. These are the two trends to be discussed and reflect upon in this text. We will use them as guidelines to facilitate a better understanding of these historical figures, analyse emerging contexts and concepts and propose an interpretation of this subject.

\cdots

In her book *Dancing Machines* (2003), Felicia McCarren, dance researcher at Tulane University in New Orleans, opens the introduction with a statement that has inspired this theme, and this essay in particular: referring to the central premise of her book, choreographies at the age of mechanical reproduction, the author situates her reflection on dance and technology in the context of a curious anecdote regarding the tragic circumstances in which Isadora

Duncan passed away in Nice in 1927, at the age of fifty. Part of the aura surrounding Duncan is owing to her extraordinary demise: while travelling in the passenger's seat of an Amilcar GS, which legend subsequently turned into a glamorous Bugatti, she was strangled when her scarf became entangled in one of the car wheels.[1] For McCarren, this fact, the stuff of celebrity gossip and paparazzi publications, becomes a powerful metaphor that contrasts the automobile—archetypical symbol of the mechanical reproduction and industrialisation of the 20th century—with the foremost exponent of naturalistic and humanistic dance, Duncan.

This leads us to an interesting paradox, which actually underpins this entire text, suggesting the existence of parallel paths that ran throughout the 20th century, with technological breakthroughs applied to art on one side and the utopian notions of the natural body, untouched by external intervention, on the other. The 1920s modernist imaginary of Fritz Lang's *Metropolis* stands in opposition to the nudism and the quest for the inner self through nature practised by the "life reformers" at Monte Verità.

Exploring the origins of modern dance requires addressing very different themes that encompass a vast range of reflections and interests which are forever intersecting. On the one hand, we have the turn of the century as a socio-cultural, political and territorial phenomenon that changed people's lifestyles dramatically and permanently, as well as the ways in which technology developed and permeated every aspect of society.

In the latter years of the 19th century, one radical transformation followed another. The accelerated pace of life brought about by the Industrial Revolution became the standard for measuring time in society. In an era of social upheaval in Europe, of workers' movements, women's campaigns and struggles and mass warfare, intellectuals and artists were seduced by these changes and events, which set the pace for a crucial period in history.

In the midst of this maelstrom it is important to step back in order to get a bigger picture of the entire era and the themes I have proposed. Thus, one of the aids I am going to use to facilitate an appreciation and interpretation of the zeitgeist of those days is the concept of technological transformation, in its broadest sense and sphere of influence. In this respect we must return to the initial metaphor, which speaks to us of production models, serialisation, industrial forms and the dramatic repercussions of all of these proposals for the entrepreneurial-productive mindset. This was first embodied in Frederick Winslow Taylor's scientific management principles regarding production and the workplace, the purpose of which was to optimise tasks in order to increase productivity; and subsequently perfected by automobile mogul Henry Ford, who introduced the concept of assembly-line production that revolutionised the working world.

Taylor's scientific paradigm and Ford's specific application of technology not only created the production matrix that would define the 20th century, but also altered the corporeal form of social relations, at once mechanising and configuring the mentality and individual structure of the labour force. Once again, Lang's metaphor offers an illuminating insight into this theme.

Both Fuller and Duncan led unusual lives, characterised by extraordinary incidents, exposure to public scrutiny, glamour and moments of great turmoil. At the dawn of the 20th

[1] There is something both fascinating and tragicomic about the fact that Duncan, Jackson Pollock (1956), in his convertible Oldsmobile, and James Dean (1955), in the famous Porsche 550 Spyder, are all iconic figures in American art and popular culture who shared a similarly tragic fate in motoring accidents.

century, Paris was the epicentre of the world's cultural and social activity and, as such, the ideal place for these women to develop their particular visions of dance.

Born in the United States in 1862, Loïe Fuller moved to Paris in 1892 and created her most powerful works there. From the beginning of her career as an artist, she cultivated an active interest in the world of theatre and entertainment. As an avid author and a fan of popular art forms, vaudeville offered her the freedom to develop her performative expression and a space in which to experiment. Thus, she developed a vision of stage techniques and design that would become increasingly complex as her career progressed.

In the late-19th century dance had begun to undergo a series of radical transformations with important repercussions for its subsequent development. One was the disappearance of the few remaining traces of Romantic ballet as such; another was a dual phenomenon in academic ballet that affected style, aesthetics and teaching methodology. This duality is evident in the works of Michel Fokine, Vaslav Nijinsky and the Ballets Russes on the one hand, which revolutionised the spirit of ballet from within (exemplified by the panic and uproar caused by Nijinsky's *Rite of Spring* in 1913), and on the other in the groundbreaking works of the classical Russian school, in which Marius Petipa and Lev Ivanov introduced a new concept of "the classical" as an aesthetic, corporeal and identity-defining structure.

Within the multiple folds of ballet culture, the motion arts occupied a historical spectrum that would soon be completely transformed. Changes were afoot in every sphere of society and this was mirrored in dance, which embarked on a profound process of reform.

Fuller, Duncan and Ruth Saint Denis are traditionally regarded as the pioneers of a new type of movement, a new trend in dance, a theatrical avant-garde that had begun to germinate in the latter days of the 19th century and grew into a full-blown phenomenon during the first half of the 20th century.

These new figures on the dance scene began to experiment without knowing that what they were doing would be hailed, in the fullness of time, as the foundation of modern dance. What they did realise, without a shadow of a doubt, was that they were part of a transformation in progress. But why describe it as such? Here again theorists and researchers diverge, but permit me to propose the following hypothesis: although the aforementioned authors embody a new departure that contains unequivocal signs of the avant-garde, this concept was not sustained in its discursive and disciplinary consummation. This is basically because one of the fundamental elements of an

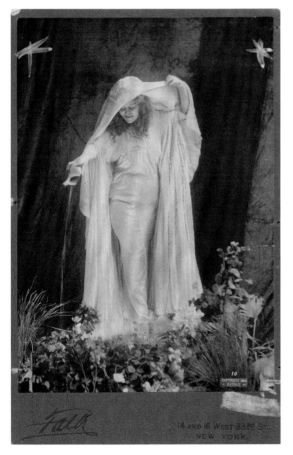

Benjamin J. Falk
*Loïe Fuller Posing
in Her Salome
Costume above
a Floor Lighting
Fixture*, 1896
(cat. 18)

avant-garde trend, understood as the transformation of an artistic process, is self-awareness and the possibility of classifying that change as a "movement". In Fuller, Duncan and Saint Denis we see far-reaching initiatives that signal very different approaches to motion and dance, but not a project designed to transform the entire discipline.

It is in this sense that Fuller introduced several key operations for the winds of change sweeping the dance world. On the one hand, she blended and strove to overcome the differences between high culture and popular culture. In other words, she bridged the gap between the venues and contexts enjoyed by the populace, embodied by the Folies Bergère, and the lofty figures of high culture that saw their works as a vital inspiration, such as Auguste Rodin, the Symbolists (represented by Stéphane Mallarmé), the Futurists and the artists who subscribed to the Art Deco movement.

Fuller transformed the skirt dance that was all the rage in England in the late-19th century into a more complex, abstract dance at the same time that she conducted her first experiments, filling her performances with visual effects, lights and magical contraptions that epitomised the new ways of engaging with technology. At this point in time, electricity was only just beginning to reach the masses as a public commodity, photography was emerging as a new and more visible form of the image and cinema was in its infancy. This was the context in which Fuller developed her own method for producing works, as a form of cultural appropriation and performative intelligence that sought to integrate different languages that had never before occupied the type of common space that Fuller would ultimately create.

In this way, as a choreographer, lighting technician, inventor of visual effects and filmmaker, she gradually constructed a new model of theatrical performance that was widely imitated and copied throughout Europe and the United States. While the skirt dance was popular in many different cultures, the theatrical nuances that Fuller introduced combined a variety of techniques, including the projection of coloured lights from different angles, slides with images and visual effects with mirrors that played with the audience. Fuller therefore became an innovator for the art of her day. The importance of her work in terms of kinetics is vital for understanding her oeuvre. As renowned American dancer and dance theorist Ann Cooper Albright notes in her excellent book *Traces of Light* (2007), scholars have traditionally analysed Fuller's work as based and built upon the visual effects of colour and light, overlooking the many innovations she introduced in terms of a style of movement and a highly complex explo-

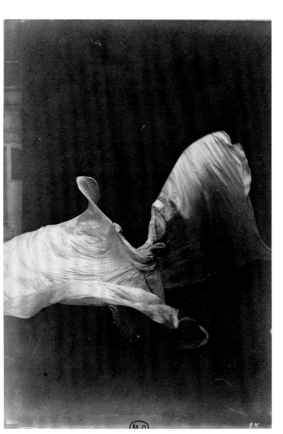

Isaiah West Taber
Loïe Fuller Performing the Final Toss and Enveloping Twirl of Her Veil in the Lily Dance, ca. 1902
(cat. 63)

ration of the body. The subtitle of Albright's book, "Absence and Presence in the Work of Loïe Fuller", alludes to the presence and absence of that body on stage, where it is only perceived through light, which acts as a moving screen, as dematerialisation, as motion itself. Fuller conveyed this herself in a famous and frequently quoted section of her autobiography, noted by Sally Sommer in her celebrated article published in 1975 in *The Drama Review*: "What is dance? It is motion. What is Motion? The expression of a sensation. What is Sensation? The reaction in the human body produced by an impression or idea perceived by the mind." Sommer adds that these words contain a reflection about dance where motion, not the body, is the principal element in the stage design: "By motion she was not only referring to the dancing body but to the motion of the light, colour and silk as well. She danced light, colour, costumes, and through motion her body fused into a visual image. Fuller conceptualised an image in motion created by multicoloured lights, playing in a perpetual motion of silks."[2]

Fuller therefore presents an abstract conception of motion in which her own presence is diluted—though not her way of executing motion—and where she experiments with modifying her body by lengthening the fabrics of the skirt dance and creating a system for manipulating them with long rods. These costume devices allowed Fuller to explore complex kinetic ways of visualising her body in motion, and it is these innovations that inspired Albright's theory about presence and absence in Fuller's corporeality and stage designs.

Rhonda Garelick, a scholar at Connecticut College, approaches Fuller's work from a more conceptual perspective, with occasional references to her life, and puts forward various hypotheses. One of them is related to Fuller's figure both on and off stage. In her book *Electric Salome. Loïe Fuller's Performance of Modernism* (2007), Garelick ponders the reasons for Fuller's disappearance from the scene and why she was overlooked for so long as a major figure in the dance world. According to Garelick, for whom the dematerialisation of Fuller's body was in part a burden that made her more famous off stage than on it, this fall into oblivion was provoked by the internal logic of her work.

This is a crucial point for establishing the internal mechanics of Fuller's stage designs because it ties in with the very intention of dance: the abstraction of the body in order to appreciate corporeality through light, or lighting, and the partial concealment of the body on stage. Concealment and disclosure open up an array of highly attractive concepts. On the one hand, we have the idea of a body emerging from an absence that is motion, but we also see how, since the birth of modern dance, this provokes a reflection that situates the dance on stage, but without a visible body—something which is difficult enough for dance as an art form, but even more so for a modern tradition which materialised and presented all of its practitioners through gesturality and the portrayal of roles and characters reinforced by stage designs that inevitably conceived the body as the centre of the theatrical space.

This is why the official history ignored the first pioneer of modern dance—to the benefit of figures like Duncan, Saint Denis and, later on, Martha Graham and Mary Wigman, who glorified the importance of the body on stage—and Fuller was relegated to a very minor role in that history. Garelick touches on this with two highly illuminating quotations. One

[2] Sally R. Sommer, "Loïe Fuller", *TDR/The Drama Review*, vol. XIX, no. 1, TISCH School of the Arts, New York University (March 1975), p. 54.

is from a press article published on 4 January 1928, the day Fuller passed away, which notes the circumstances of her death and describes her as a follower of Duncan's dance style; the other alludes to the secondary role played by Fuller and describes her as a very strange person with a peculiar physique.

Nonetheless, Fuller did have an enormous impact on the early avant-gardes. As a stage persona, she was renowned for her abstract conception of dance, employing concepts that are only just beginning to bear fruit and be taken up by new generations. Meanwhile, in the mid-1990s, various authors in different parts of the world began to research Fuller, giving new impetus to the study of her figure. Giovanni Lista, Felicia McCarren, Tom Gunning, Jody Sperling, Rhonda Garelick, Ann Cooper Albright and Richard and Marcia Current are just some of the prominent scholars who have published books and articles on Loïe Fuller, some from a more conceptual point of view, some from historical perspectives, and yet others with a more biographical approach. Meaningfully, these texts and the renewed interest in the figure of Fuller coincide with a particular juncture in dance. In my opinion, this is because contemporary stage designs frequently experiment with the image, with visual and digital effects. In other words, there is a genealogical gesture that has resuscitated Fuller in order to contextualise and elucidate the long-term relationship between body-dance and technology. In fact, this revived interest has grown so intense that there is now a commercial for video cameras in which Shakira uses the dance model invented by Fuller. Thus, and in a particularly dramatic way, one of Loïe Fuller's intentions has now become a reality: namely, the aforementioned fusion of art and popular culture, which is clearly if perhaps somewhat grotesquely achieved with Shakira's imitation of Fuller.

Naturalism, Romanticism, Revolution

Karel Reisz's film about the life of Isadora Duncan (*Isadora*, 1968), magnificently portrayed by Vanessa Redgrave, narrates aspects of her public persona that highlight the misery and chaos of her real life. Duncan occupies a central place in the history of dance because, in addition to pointing the logical way forward for dance as an art form, she was

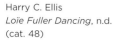

Harry C. Ellis
Loïe Fuller Dancing, n.d.
(cat. 48)

the most influential female pioneer of modern dance. Furthermore, her notorious public life made her world-famous.

We can identify at least four crucial moments in Duncan's work: an early phase associated with the return to the classical Greek world, inspired by ancient vases and Botticelli paintings; a naturalist phase associated with the Monte Verità commune; a more expressionistic phase; and a phase related to social engagement, when she travelled to Russia in 1921, during the early years of the revolution. Her struggle for women's rights, her poetry and her manifestos about the woman of the future are fundamental contributions that cannot be overlooked when examining the life and work of this dancer. One of the aspects I would like to explore is the idea of the body as presence, the quest for an onstage corporeality free of constraints and the concept of expressionism evident in her later works.

In her writings about dance, Duncan says that in order for dance to be reborn one must travel back to a long-lost image and recover the motion, or the idea of motion, of the ancient Greeks. This gesture, which as I have already mentioned is well-documented by dance historians and theorists, is particularly interesting because it clearly illustrates how a static, centuries-old image inspired a new form that was revolutionary in Duncan's context. Thus, the stillness of the image is echoed in a present body, in a corporeality that needs to be viewed in its full dimension and requires a strong idea of presence: the exact opposite of Fuller's case. An abstract visual expression is transformed into motion in an appropriation and nostalgic quest for the past that needs to be recast in the present, delving into the most primitive notions of the body and its representations. And, as with many philosophers and thinkers, the Hellenic world evokes these reflections and perspectives.

Showing that body led Duncan to explore its primeval state and to establish a connection with the idea of nature, from which she retrieved her definitions of harmony and life, inextricably linked to her personal vision of dance. Armed with these theories, Duncan proceeded to champion the freedom of human beings and, in direct opposition to this, viewed ballet as a metaphor that imprisons the body.

Harry C. Ellis
Loïe Fuller Posing, n.d.
(cat. 59)

In analysing her influence we come across Fokine, one of the leading ballet reformers of the early-20th century, who created a work inspired by Duncan's dance style and never lost his complete and utter fascination with her. That work was performed by Anna Pavlova and Nijinsky, two essentially disruptive figures within the ballet world whose far-sighted reflections on dance coincided with the new direction that the discipline was taking at the beginning of the century.

For Duncan, the only principles of the body were those dictated by nature, the sea and the wind, allegories that formed the cornerstone of her philosophy and which she translated into a kind of choreographic, aesthetic and pedagogic composition. Her idea of connecting different parts of the body, with the physical, emotional and spiritual planes converging at the solar plexus, denotes a conception that centralised motion in the body and from the body.

The construction of a corporeal ethos and imaginary are desires that Duncan reflected in her works. Although few traces of her oeuvre remain, there is a kinetic tradition that has been passed down from generation to generation which emphasises this idea from the first phase of Duncan's work; not so the stronger, non-conformist approach to motion reflected in her Expressionist streak.

Duncan was always drawn to the pedagogic side of dance, a circumstance that experts believe stemmed from the death of her two children. During her years as an artist, she opened many schools and taught children. Moreover, the so-called "Isadorables"—the group of girls she adopted as daughters—were the star performers in her works, and after she died they took it upon themselves to preserve her legacy.

Analyses of Duncan's time in revolutionary Russia usually focus on her controversial relationship with the poet Serguei Yesenin and tend to overlook a fascinating aspect which we glimpse in her work *Revolutionary* (1921), where she explored the notions of the free body and the revolutionary process. Magnificently captured in Reisz's film, this work reveals a crucial hallmark of this final phase in Duncan's career: her approximation to Expressionism, with a special emphasis on gesturality, most notably on the expression of the face and hands. This reinforces the idea that, for Duncan, dance was a body that conveyed meanings in their fullest sense. In a scene from the aforementioned film, Duncan is shown wearing a deep red and black tunic, with fists raised, arms lifted to the sky and a belligerent, menacing look on her face. The shocked American audience brands her as a communist and, after hurling a string of insults, stages a mass walkout. The show ends with Isadora in the nude, to the indignation of the few remaining spectators in the hall.

This later development in Duncan's work opens up an interesting field of discussion. The work-life and life-work relationship is something that ties in very directly with a particular type of stage corporeality. While Loïe Fuller explores the hybrid idea of the body, emphasising traits that transcend the body itself, like light and its combination with motion, Duncan clings to the theatrical strength of the body, to its presence, and although she seeks its natural qualities she also deliberately and very succinctly conveys its meaning. The body can only be freed by confronting it from within.

Hybrid bodies, natural bodies and technological bodies intertwine in onstage presences and concealments. Fuller and Duncan shared a common vision of dance: the need to cast off its academic constraints, to push the envelope. But from that point on their paths diverged: one was immediately adopted by modern dance while the other is still waiting to be rediscovered conceptually; one describes the presence and exaltation of the body while the other occupies the interstices between revealing and concealing, between appearing and disappearing through motion.

Bibliography

Banes, Sally, *Dancing Women. Female Bodies on Stage* (New York: Routledge, 1998).

Cooper Albright, Ann, *Traces of Light. Absence and Presence in the Work of Loïe Fuller* (Middletown, Connecticut: Wesleyan University Press, 2007).

Current, Richard Nelson, and Marcia Ewing Current, *Loïe Fuller. Goddess of Light* (Boston: Northeastern University Press, 1997).

Duncan, Isadora, *The Art of the Dance* (Ann Arbor, Michigan: University of Michigan, 1992).

Franko, Mark, *Dancing Modernism / Performing Politics* (Indianapolis: Indiana University Press, 1995).

Fuller, Loïe, *Fifteen Years of a Dancer's Life* (London: H. Jenkins, 1913).

Garelick, Rhonda K., *Electric Salome. Loïe Fuller's Performance of Modernism* (Princeton, New Jersey: Princeton University Press, 2007).

McCarren, Felicia, *Dance Pathologies. Performance, Poetics, Medicine* (Redwood City, California: Stanford University Press, 1998).

McCarren, Felicia, *Dancing Machines. Choreographies of the Age of Mechanical Reproduction* (Redwood City, California: Stanford University Press, 2003).

Pérez Soto, Carlos, *Proposiciones en torno a la historia de la danza* (unpublished, 2006).

Sommer, Sally R., "Loïe Fuller", *TDR/The Drama Review*, vol. XIX, no. 1, TISCH School of the Arts, New York University (March 1975).

Thomas, Helen, *Dance, Modernity and Culture. Explorations in the Sociology of Dance* (New York: Routledge, 1995).

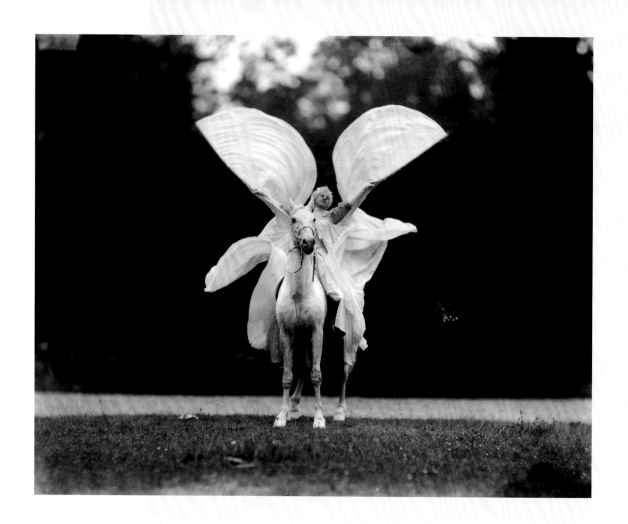

Louis-Jean Delton (junior)
Mlle Thérèse Rentz in La Loïe
Fuller on Horseback *(a Show
Featuring Pegasus Set in the
Belle Époque Years)*, 1904
(cat. 114)

La Cavalière ailée [The Winged
Horsewoman], ca. 1934
(cat. 115)

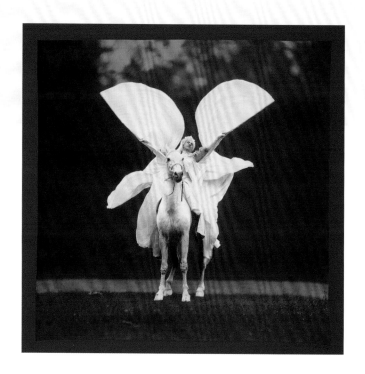

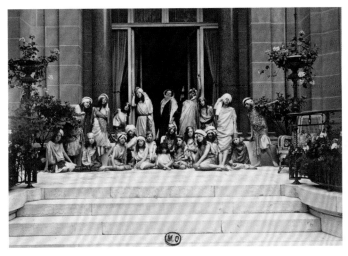

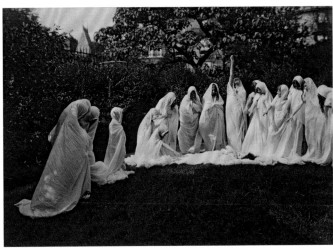

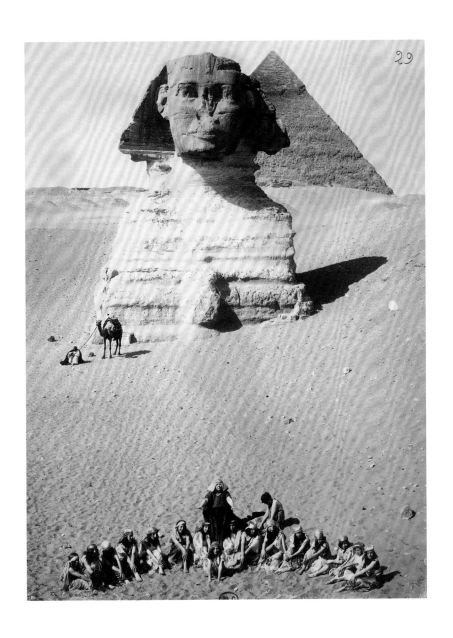

Harry C. Ellis
*Loïe Fuller and Her Students
at the Entrance to Mme de
Polignac-Singer's Home (?)*, 1914
(cat. 116)

Harry C. Ellis
*Students of Loïe Fuller Dancing
in a Park*, 1914
(cat. 117)

Harry C. Ellis
*Loïe Fuller Posing with Her
Students before the Sphinx
at Giza*, 1914
(cat. 118)

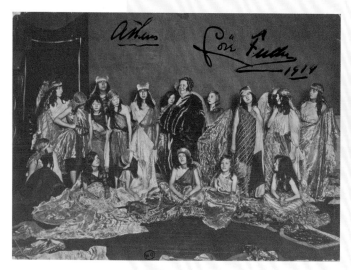

Harry C. Ellis (attributed)
*Loïe Fuller Posing with Her
Students in Athens*, 1914
(cat. 119)

Harry C. Ellis
*Loïe Fuller and Her Muses
in Prince Troub's Garden*, 1914
(cat. 120)

Salón Variedades Programme, 1912
(cat. 122)

Hana
Performance of Pays des oiseaux
sacrés *[Land of the Sacred Birds]
at Paris' Théâtre national de
l'Opéra*, 1920
(cat. 121)

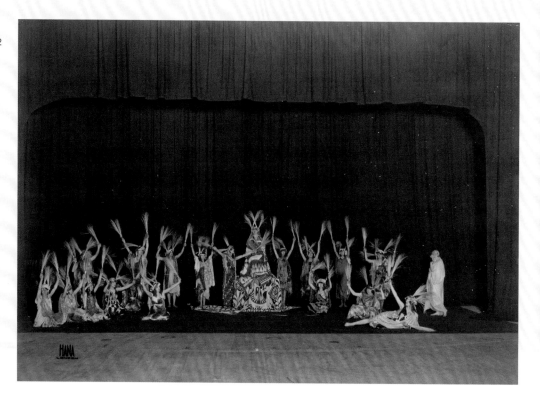

*Reel of Dancer Images
for Cinématographe Jouet*, n.d.
(cat. 124)

*Child's Mutoscope and Reel with
Serpentine Dance Sequence*, n.d.
(cat. 125)

Cinématographe Jouet, n.d.
(cat. 123)

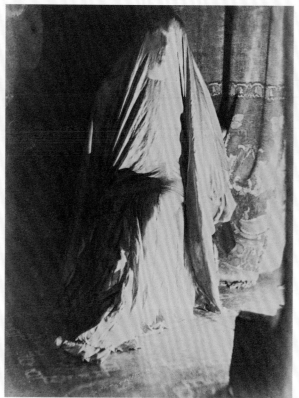

*Dancer Imitating Loïe Fuller
Performing the Butterfly Dance
at Night*, 1904
(cat. 126)

R. Moreau (attributed)
Loïe Fuller with Veil, n.d.
(cat. 128)

Loïe Fuller, n.d.
(cat. 127)

R. Moreau (attributed)
*Loïe Fuller Posing with
a Lighting Device*, ca. 1900
(cat. 129)

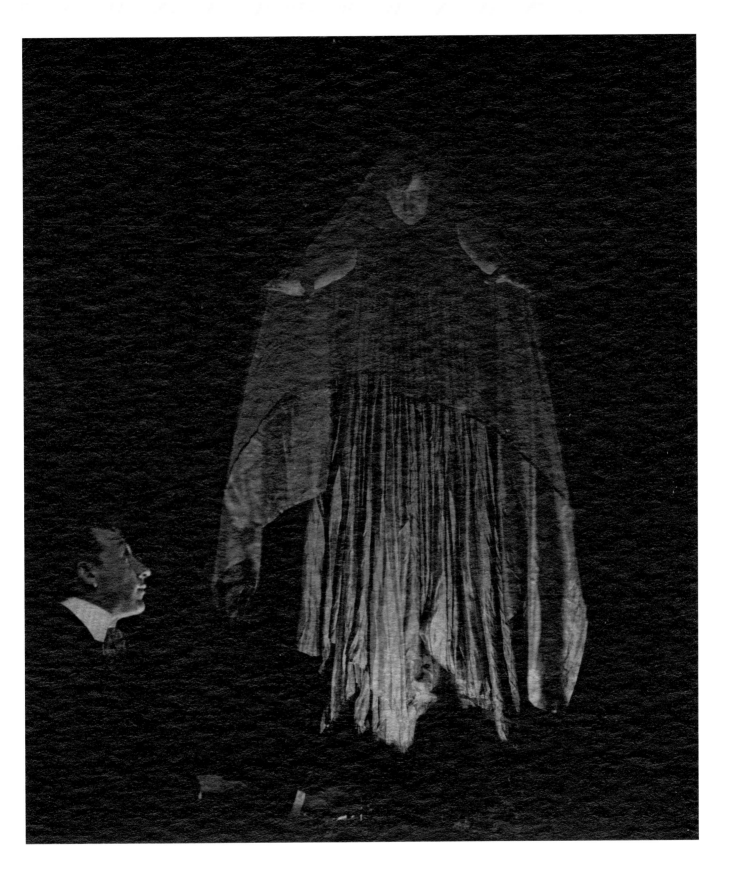

My Life and Dance[*]

Loïe Fuller

Dance

Nature is our guide and our greatest teacher.

But we do not observe it.

No two things are of the same nature or exactly the same; the spirit that moves them is the same, but each object responds in its own way to the great driving force in nature, that part of us which is divine!

The leaves move in harmony with the wind, but each leaf moves in its own way.

The waves of the sea are never the same and yet they are all in harmony.

And so we must realise that the law of momentum is one thing; the law of harmony is another.

Simply "following nature" is not harmony; harmony is a great ensemble of many small details which move, as in music. As in dance. The rhythm of the feet is one detail, the movement of the body and the arms is another, the way the head is held and the look in the eye. These are all necessary to complete this great ensemble.

Perfection lies in the unity of movement, which we might call "vision music" or "music for the eye", since harmony in movement is to the eye what music is to the ear. But perfection means exactly the same as within nature. So instinct and spontaneity are the only teachers. The eye, more penetrating than the ear, the eye, unlimited in its capacity, which sees without limits on its visual horizon, is more elevated and greater than any other physical quality in the human being. The eye can see more music than the ear can understand. Dance today is learning its alphabet, at the point when music will discover its origins.

The eye creates its world, without any need for the education that has made music from sound. The eye has a far vaster perception than the ear. The sense of sight is much keener than the sense of hearing, from which we can deduce that perfection in movement is a music that one day will take its place among the highest artistic expressions known to man.

But to attain perfection, dance or movement must develop from an absolute freedom of expression.

However beautiful a movement may be, when done and repeated with a certain rhythm, it is no more than a reflection of the truth.

* Extracts translated from Loïe Fuller, *Ma vie et la danse. Suivie de écrits sur la danse*, texts compiled and presented by Giovanni Lista (Paris: Éditions l'œil d'or, 2002), pp. 171–172 and 177.

A famous dancer inspires the arts to copy her. But she must not be a copy herself. The same dance, seen again and again, should be like leafs in a tree, which are never exactly alike.

Movement is an instrument through which the dancer casts vibrations and waves of visual music into space, skilfully expressing for us every human and divine emotion. That is dance.

Theory of Dance

When a dancer leaves the stage, the outline of her dance, were we to be able to see it, would be as perfect in its symmetry as a piece of lace.

To be round, for instance, a circle must be complete. The forms and rhythms in the movements and figures by which dance is recorded on stage should also be this way.

Doing nothing and doing it well should be necessary in a dancer's light and shade, like a moment of silence in an orchestra or a momentary lull when the wind is blowing.

We should know what they desire and what they mean to say, and then do it.

The body, which, out of inexperience, at first expresses very poorly what the dancer feels, will surprise you with the results of "effects" and "time".

To learn to walk takes time, just as it does to hold a pen. Patience, resolve, perseverance and endeavour bring about the expression of the soul, just as a seed needs time to become a tree.

The ABC, or alphabet, of dance is movement in chaos. Gradually, the movements intensify and, with time, surprise everyone.

Most people believe that music is the very foundation of dance.

A great dancer has no need of music, because music restricts her in her movements and that is not total freedom. And the greatest dancer needs the greatest possible freedom.

Talent follows others. Genius creates something new, never seen or known before.

But everything must be created from what already exists, putting together a bit of this and a bit of that; for everything we see or know, or we do not see and do not know, comes from the black earth on which we tread and from the fingers and the brain of man.

Rembrandt gave the world a new school of painting, but to do so, he used old things.

Beware of Imitations!

La Ribot

How can we dance a tribute to Loïe Fuller today?

We dive into one of her greatest contributions, the most abstract and transcendental of them all. We step into the black box, embracing her great invention: Loïe Fuller divested the stage of the concrete. She proposed a performative space of experimentation where abstraction, transformed into infinite blackness, allowed her heirs to carry on her work throughout the 20th century, and even today in the 21st. Fuller's black stage incorporated electricity, fluorescence, chemistry and printed colours, creating a compendium of the greatest inventions of her time. In a subtle way, the use of this black background dialogues with the symbolism of her era while also hinting at the future to come.

Now, nearly a century and a half later, we have staged another experiment with light and technologically synthesized motion. Today's possibilities resolve those early steps in one fell swoop. A small portable camera and a plasma screen condense a century of performative and cinematographic experimentation: two small domestic devices that virtually anyone can acquire.

Just as the rods and filmy silk fabrics served as an extension of Fuller's arms, so a lightweight Handycam, held in my hand like a prosthesis, becomes an artificial extension of my body. Just as she painted space using lighting effects, so my body registers the space like a deepsea diver exploring the abyss, as the camera reveals its audiovisual properties.

There are two bodies in this film: that of Carles Santos, behind the piano, and mine behind the camera. The former is concrete, visible and even allegorical, experimenting on the piano as if it were a whale, a leviathan that Santos strives to tame and conquer like a modernday Captain Ahab. My body, on the other hand, is nearly invisible, like a mental projection of the space in motion, thanks to the periscope-camera.

La Ribot
Beware of Imitations!, 2013
(cat. 130)

Biographical Sketch

In 1908 Loïe Fuller wrote her autobiography, which covers most of the key events of her times, life and work. Brimming with details and theories about dance and the scientific wisdom of her day, as well as her personal impressions, the memoirs offer us an unparalleled insight into Fuller's figure. The exceptional quality of this text is exemplified by one fact in particular, though there are many others: Isadora Duncan, to whom almost the whole of Chapter 20 of the autobiography is dedicated, is never mentioned by her name.

In 1994 Giovanni Lista published *Loïe Fuller, danseuse de la Belle Époque* [Loïe Fuller, Dancer of the Belle Époque], a vast and exhaustive study of the artist's life and work reconstructed from copious primary and secondary sources, archives and bibliographies. The book includes numerous biographical details that offer a vital aid for examining Fuller's life; the biographical sketch presented here is largely based on that monograph.

Thanks to the insights of other experts on the work of Loïe Fuller, such as Rhonda K. Garelick, Ann Cooper Albright, Felicia McCarren, Elizabeth Coffman, Sally R. Sommer and Brygida Maria Ochaim, as well as to the research carried out at the Bibliothèque nationale de France, the Musée Rodin in Paris and the New York Public Library, we can create the following timeline—albeit incomplete—of the key milestones associated with the figure of Loïe Fuller.

- Marie Louise Fuller, known as Loïe Fuller, is born in Fullersburg, Illinois, near Chicago, on 15 January 1862.

- At the age of two and a half she recites a poem at the Progressive Lyceum in Chicago, demonstrating, even at that early age, a clear vocation for the stage.

- By the age of four she is acting with amateur theatre companies, and at twelve she recites Shakespeare in a dramatic reading at the Academy of Music in Chicago.

- Until the age of twenty-two, Loïe is cast in minor roles, reciting prose and verse or playing instruments like the banjo.

- In 1884 she abandons the theatre to take up opera and singing, performing with opera companies and academies in Chicago and New York. In 1887 she makes her dancing debut in a variety show.

- In 1889 she marries American businessman William B. Hayes, whom she abandons not long after. That same year, she founds her own company, touring the United States, Bermuda, the Antilles and Jamaica.

- In late 1889 Fuller is offered the role of Mercy Baxter in a production of *Caprice* at the Royal Globe Theatre in London. This role in Howard P. Taylor's four-act play encourages her to travel to Europe. London at the turn of the century is one of the great "ports of entry" for information, culture and the future of the world.

- In 1889 she also joins the Gaiety Theatre Company in London, playing minor roles and receiving her first dance lessons, having had no formal training whatsoever until this point. The first thing she learns is the so-called "skirt dance", a variation on the can-can and vaudeville dances.

- In the autumn of 1891 she plays the part of Imogene Twitter in Fred Marsden's production of *Quack Medical Doctor* at the Boston Opera House. It is then that Fuller conceives an idea that would be decisive for her future career. Dressed with a large chemise with long and wide sleeves, she draws a series of movements with her arms and hands that, supported by the projection of various coloured lights on her figure, create a hypnotic effect. It is the starting point of the aesthetic innovation that characterised her career, opening a new path of choreographic experimentation.

- The aforementioned performance contains the seed for the innovations Fuller introduced a few months later in what has come to be known as the "serpentine dance". Rather than a new interpretation of the past—as in the case of her fellow dancer Isadora Duncan a few years later, whose experiments reflect the line of work advocated by many historians and philosophers of the day—Fuller's exercises explore new ways of viewing reality and understanding both the body and motion. Thus, at the beginning of 1892, she presents her new dance, which is immediately christened as the "serpentine dance" by Rud Aronson, the impresario who hires her for the Boston Theater.

- The originality of the performance and its impact on audiences brings Fuller huge success. After breaking with Aronson, she tries to patent the serpentine dance, but the very same year of its debut, it is plagiarised by the dancer Minnie Renwood Bemis.

- In the autumn of 1892 Mabelle Stuart performs the serpentine dance at the Folies Bergère with Fuller's consent. The deluge of imitators—only several of whom have Fuller's consent—has only just begun. Although this clearly helps to disseminate her work around the globe, at the same time it frequently distorts its essential nature.

- Fuller becomes interested in the experiments with phosphorescent materials, radioactive salts and X-rays that Thomas Alva Edison is conducting at his laboratory in New Jersey. There, she witnesses first hand his experiments with back light, based on boxes whose inner walls are painted with radioactive oils that emit light through a transparent lid, producing startling effects. Loïe explains to Edison that she wants to work with these materials and effects on stage. Thus begins a long period of experiments with the power of light and materials impregnated with light-emitting radioactive substances.

- In 1892 Fuller and her mother move to France, setting up residence at the Grand Hôtel in Paris. Thus, at the age of thirty, Loïe abandons her native land, choosing Europe, and Paris in particular, as her new home. Although she will return to the United States on countless occasions, the bonds she establishes with Paris from that moment on—her contract with Édouard Marchand, director of the Folies Bergère; her new friends and acquaintances; and her access to cultural circles and a European society hitherto completely unknown to her—mark a turning point in Fuller's life, both professionally and personally.

•

On 5 November 1892 the serpentine dance receives its official debut in Paris. Assisted by twenty-seven lighting and electricity technicians, Fuller performs four pieces: *Serpentine*, *Violet*, *XXXX* and *Butterfly*.

•

During the course of this first season, which lasts several months, Loïe, eternally inspired by nature, introduces several new pieces, entitled *Rose*, *Chalices* and *Pansy*. Her shows are a resounding success with the general audience. Fuller also begins to attract the attention of artistic (Symbolist in particular), cultural and high-society circles.

•

In 1893 Fuller is caught up in a frenzy of activity, alternating her stage performances with her research. That year she files four patents, in Europe and the United States, for various costumes and stage devices. The first patent is for a new costume specially designed for her dances. The second one is for a back-lit floor that creates a new type of atmosphere. The third patent is for stage scenery comprising white walls studded with faceted stone nail heads that reflect and decompose the light reflected on them. The final patent is for a stage set made up of specially treated intersecting panes of glass that produce a kaleidoscope effect on the walls and backdrop.

•

Fuller's performances at the Folies Bergère not only brings her into the public eye but introduces her into aristocratic circles; Paris at this time being the adopted home of princesses from different European courts. The relationships she develops with members of the aristocracy will subsequently provide a crucial source of funding and publicity for some of her shows.

•

In the summer of 1893 Loïe travels to New York to present her dances with magic-lantern projections, based on new experiments with stage lighting, at several of the city's entertainment venues, including the Garden Theatre. She returns to Paris for the first anniversary of the serpentine dance debut at the Folies Bergère, where she introduces new pieces, such as *Dance of Clouds*. The autumn season at that theatre also provides her with the opportunity to add new theatrical innovations to her repertoire, with works like *Dance of Fairies*, which she performs with the ballet section of her company, including Madame Martins, Mercedes I, Vleminck, Brocard, Mercedes II and Delorme. This highly successful season ends with Fuller breaking off her contract with the Folies Bergère impresario Édouard Marchand. She subsequently tours with her show to London, Brussels, Antwerp and numerous cities in northern Europe.

•

In 1895 she returns to Paris and presents *Salome*, Charles H. Meltzer's two-act lyrical pantomime, with stage design by Georges Rochegrosse, at the Comédie-Parisienne. At the end of the work, she performs a new suite of serpentine dances: *Black Dance*, *Sun Dance*, *White Dance*, *Dance of the Rose*, *Lily Dance*, *Salute to the Sun*, *Lightning* and *Tempest*.

•

She ends the year 1895 with a major tour of Great Britain, constantly incorporating new pieces, such as *Night*, *Firmament*, *The Lily of the Nile* and *Mysterious Dances*, to name but a few.

•

At the beginning of 1896 she returns to the United States, where she presents the new pieces she has created in the previous years at venues in Boston and New York.

•

Thomas Alva Edison's laboratory, which Fuller had visited several years earlier, closes due to the illnesses that the researchers have contracted by working with radioactive substances. Far from putting Fuller off her career as a researcher, this circumstance persuades her to open her own laboratory, which she manages to do several years later, in 1905, in Paris.

•

Her shows become increasingly sophisticated from the technical point of view and now require the assistance of up to twelve lighting technicians or electricians. In 1897, at a new appearance at the Folies Bergère with *Lily Dance* and *Dance of Fire*, she hires as many as thirty-eight lighting technicians. The size of her team and technical apparatus, coupled with the management and supervisory aspects of the production, give us an idea of just how technological her performances have become. For Fuller, dance, theatre and technology are inextricably bound together in a type of symbiosis. Today, a full century later, her theories have not lost a single shred of their relevance.

•

In 1897 she meets the person who will accompany her for the rest of her life as lover, producer and coordinator: Gabrielle Bloch, known as Gab. This is also the year that Fuller leaves the famous Grand Hôtel—living in luxury hotels was a common practice among the artists of the day, even if it was often above their financial means—and moves with her mother to a private residence at number 24, Rue Cortambert, in Paris. In the garden of this house she produces pieces like *Miriam's Dance*, *Dance of Madness*, *Flower Dance* and *Blind Dance*.

- By the turn of the century, Fuller is performing at the most prestigious venues in Paris. One of her most important performances takes place at the Olympia theatre in 1899, where she presents *The Sylphs*, *Dance of Gold*, *Lights and Shadows* and *Archangel*. In the case of the latter piece, she patents several devices composed of mirrors that reflect and multiply the images, turning them into a type of "unreality". Fuller's work attracts enormous acclaim and the admiration of writers, painters, sculptors, inventors and scientists across Europe and the United States. In short, she is venerated by all those who are beginning to form the entertainment society.

- In 1900 Fuller erects her own pavilion at Paris' World's Fair to showcase her work and her use of electricity through theatrical performances and the exhibition of objects. The pavilion is designed by Henri Sauvage and features a number of sculptures, including one at the main entrance created by her great admirer Pierre Roche. The pavilion represents a crucial exponent of the debate about structure and surface in the Art Nouveau architecture of the day. In addition to performances by Fuller, it hosts those of the Japanese company of Otojiro Kawakami, featuring his wife Sada Yacco. This is the first time that a Japanese company travels to the West to take part in an event of the importance of a World's Fair, and so great is Sada Yacco's impact on the Western art scene that many historians regard her as a pioneer of modern dance and a decisive influence on dancers like Ruth Saint Denis.

- The famous quick-change artist Leopoldo Fregoli is also invited to perform at Fuller's pavilion. His shows consist in changing his voice, costume and register at incredible speed in order to impersonate scores of different characters during the course of a single performance.

- As well as producing her own shows, Fuller designs the lighting for productions like *The Geisha and the Horseman* and *The Chinese Girl*. The programme at the pavilion also includes her luminous dances *Firmament*, *Lights and Shadows*, *Dance of Fire* and *Lily Dance*, which serve in particular to underscore the power of electricity and lighting in the symbiosis between dance and technology. The entire arts and cultural establishment visits Fuller's pavilion, contributing to her legendary status.

- The beginning of the 20th century represents the pinnacle of Loïe Fuller's career. In 1901 she presents the grand mystical musical dances at the London Coliseum: *Flight of Butterflies (Radium)*, *Dance of the One Thousand Veils*, *Storm at Sea*, *Lost Shipwrecks*, *Death's Bank*, *Fire of Life*, *Ave Maria* and *Land of Visions*.

- After meeting Isadora Duncan, Fuller invites her to join her company, which is about to embark on a tour of Eastern Europe. Still working with Sada Yacco, she travels the length and breadth of Europe, presenting new shows such as *Fluorescent Dance*.

- In January 1902 Fuller and Sada Yacco and Otojiro Kawakami's troupe present Loïe's company of young dancers for the first time. The programme consists of *Fluorescent Dance*, *Grottoes*, *Tempest*, *Dance of Fire* and *Lily Dance*.

- Fuller organises three shows to launch the career of Isadora Duncan, whom she adopts as her protégé, but after being presented in the cultural circles of Vienna and obtaining sufficient contacts of her own, Duncan leaves the company. Hurt by what she considers a betrayal, Fuller cancels the tour, breaks off her contract with Sada Yacco and dissolves her company.

- Fuller spends most of 1903 alternating shows between the United States and Bucharest, the final stop on the recently cancelled tour. There she meets Queen Marie of Romania, who will have a decisive influence on her life and become a close, lasting friend. A creator herself, patron of the arts, impresario and cultural promoter, Queen Marie assists Fuller in her business ventures and activities as an arts agent. She also sponsors public and private foundations and supports fund-raising campaigns for the sick and war-wounded.

- In Romania, Fuller presents new creations inspired by the music of Frédéric Chopin and Charles Gounod: *Funerary Dance*, *Dance of Religion*, *Dance of Fright*, *Blind Dance*, *Shy Dance* and *Dance of the Martyrdom*.

- On her return to Paris, she uses the new theatrical devices she has patented—particularly the one with mirrors—in performances of *In Space*, *Water* and *House of Butterflies* at the Théâtre Marigny.

- Fuller travels to the United States to promote Auguste Rodin's work.

- In 1904 she tours Latin America, with performances in Havana, Buenos Aires, Montevideo, São Paulo and Rio de Janeiro.

- That same year, on her return to Paris after the Latin American tour, she prepares a tribute to the Curies, whose work with radium and radioactivity she greatly admires, recognising its creative potential. The luminous dances, including *Radium Dance*, which she performs at their house, require such a vast team of electricians and lighting technicians that it takes two days to prepare the improvised stage set. According to the couple's daughters, and Ève Curie in particular, the entire family is astonished not only by the tricks and optical illusions featured in the show but by Fuller's use of radioactive materials to create a phosphorescent effect on the edges of the costumes (ribbons, sleeves, etc.) used in the choreographies.

- In 1904 Fuller creates a new dance company with which she tours Europe until 1906, accompanied by her entire technical crew and stage sets. The *Butterflies* mise-en-scène dates from this period.

- In 1905 she realises her dream of opening a research laboratory, located in Paris, with support and practical advice from her numerous friends in the scientific community, including the astronomer Camille Flammarion, the Curies and Charles Henry, whose *Introduction to a Scientific Aesthetic* she greatly admires.

- On 9 November 1907 she opens at the Théâtre des Arts in Paris with a silent lyrical drama entitled *Salome*, which includes *Dance of Pearls*, *Dance of the Peacock*, *Dance of Seduction*, *Dance of the Snakes*, *Dance of Steel*, *Dance of Silver* and *Dance of Fright*.

- In 1908 Dalilah Fuller, Loïe's mother, passes away. Dalilah played a decisive role in her daughter's life, supporting her and participating in all of her initiatives.

- That same year Fuller's autobiography is published under the title *Quinze ans de ma vie* [Fifteen Years of a Dancer's Life]. At the end of the year she presents a series of ballets inspired by Indian, Chinese, Japanese, Greek and pastoral dances at the Boston Opera House.

- At the end of the year, the same venue commissions her to design the lighting for the operas *Faust*, *Rigoletto* and *Lohengrin*.

- In the years remaining before the outbreak of World War I, Fuller travels to numerous countries, alternating her frenetic activities between Europe and America and presenting countless shows with her company in leading theatres, halls and casinos around the globe. Her acclaim and popularity grow with each passing day.

- In 1912 she stages two movements from Claude Debussy's *Nocturnes* (*Clouds* and *Sirens*) as well as *Dance of Hands* and *The Great Black Bird*, alternating performances in indoor venues and outdoors.

- In 1913 she meets the composer and playwright Countess Armande de Polignac, with whom she strikes up a close personal and professional relationship. Among the numerous symphonic poems they compose together is "Thousand and One Nights". There are many photographs of Fuller during this period of her life in the gardens of the homes of French aristocrats, including that of Countess Armande, where Loïe's company performs her choreographies outdoors.

- In 1914, under the new name of "Ballets Fantastiques de Loïe Fuller", the company embarks on a tour of Egypt.

- On 14 July, Fuller hosts a party on the top platform of the Eiffel Tower, where she performs *Sun Dance*, inspired by ancient Egypt. World War I has started. She moves back to the United States, where she gives lectures and donates the money she obtains from her gala performances to the war-wounded and sick. A plea for help from Queen Marie of Romania about the plight of her country mobilises Fuller to raise funds for Romanian soldiers wounded at the front. The situation in Europe is critical.

- During World War I, Fuller purchases Theódore Rivière's sculptures from his widow and sets about promoting them along with Rodin's work. One of her aims is to create the first Rodin museum in America.

- In 1914 she meets another woman who has a lasting influence on her life: Alma de Bretteville Spreckels, wife of the American sugar magnate Adolph Spreckels. The two women strike up a close friendship. Through Alma, Fuller meets Samuel Hill, who will subsequently play a decisive role in her cultural mediation work. At the time when Fuller met him, Hill, the son of a Quaker family and an eminent lawyer, was primarily interested in rail and road connections on the west coast of the United States. Fuller's enterprise is a complex one: she sets about persuading Hill to purchase works by Rodin and Rivière, among others, in order to create his own museum.

- At the end of the war, Fuller returns to Paris and forms a new dance company. By 1920 she is back at the Olympia theatre in Paris, directing the lighting for the variety show *The Fantastic Veil*.

- 1 July 1920 sees the Paris première of *The Lily of Life*, a fantasy-type work based on a fairy tale written by Queen Marie of Romania. Fuller subsequently adapts this work for the big screen and it is shown at numerous theatres and cinemas.

- Fuller and her company travel to Spain on several occasions. In February 1901 she visits the Teatro Novedades in Barcelona; in 1921 she presents *Luminous Group Dances* at the Gran Casino del Sardinero in Santander; at the beginning of the 1920s she performs at the Gran Casino in San Sebastián on two occasions, at the Teatro Eslava and Teatro Coliseum in Madrid, and at the Teatro Romea in Murcia, where she shares stage with Raquel Meller. Films of the serpentine dance have been screened at early cinemas in Spain since 1895, most notably at the Teatro Eldorado and the Saloncito Edison in Barcelona.

- 1925 is a very difficult year for Fuller, both personally and professionally, and marks the beginning of her personal decline. In January, having been diagnosed with breast cancer, she undergoes a radical mastectomy. During her convalescence, she calls the photographer Harry C. Ellis, for whom she has posed on countless occasions. In an egotistical yet highly symbolic act, she asks him to photograph her at different stages of the post-operative process, capturing the deep scars on her breast while the doctors attend to her. At the same time, Fuller experiences serious financial difficulties and is obliged to sell part of her art collection to Alma Spreckels, most notably the works she had purchased from Rivière's widow. After recovering from the surgery, she throws herself body and soul into the founding of Samuel Hill's museum in Goldendale (Washington), which will finally be inaugurated in 1940 and is now known as the Maryhill Museum of Art.

•

That same year the Exposition Internationale des Art Décoratifs et Industriels Modernes is held in Paris, where Fuller presents *The Sea*, with music by Claude Debussy. At the end of 1925 she presents her latest show at the Théâtre des Champs-Élysées in Paris: *The Sandman*. This includes the numbers *The Sandman and His Wizards*, *The Nursery*, *Night*, *The Sandman and His Children*, *Clouds*, *Moon*, *Land of Fire*, *Sea of Tempests*, *Stars* and *Gates of Light*.

•

In 1926 Fuller invites Queen Marie of Romania to visit the United States for the early opening ceremony of Samuel Hill's museum. During the queen's stay, they visit several American cities.

•

1926 is also the year that Fuller mounts a major production with her company for the World's Fair in Philadelphia, which Queen Marie also attends.

•

As part of the same tour, Fuller's company presents *The Lily of Life* at New York's Metropolitan Opera House. The production is based on a story by Queen Marie of Romania, who also attends the performance. However, during the queen's stay in the United States, numerous personal and financial problems arise between Loïe and Marie, and at the end of 1926 their long friendship comes to an end.

•

In 1927, during the final stage of her career, Fuller once again throws herself into the world of filmmaking, viewing cinema as fertile ground for experimenting with kinetic theories. However, *Visions of Dreams*, again based on a story by Queen Marie of Romania, and *The Uncertainties of Coppelius*, based on a Hoffmann tale, are never finished.

•

Fuller's fragile health and a possible tumour affecting her immune system signal that she has not long to live. She dies of pneumonia on 2 January 1928. Gabrielle Bloch, who subsequently becomes Eileen Gray's lover, takes over the management and coordination of Fuller's company, which soon breaks up into two groups. Nevertheless, both groups perform Fuller's choreographies internationally until 1950, thus contributing to the legacy of Fuller's work after the artist's death.

•

Since Loïe Fuller passed away, there have been countless examples of the influence of her work on different artistic disciplines. One of the most interesting cases is that of the Hermès fashion house. Émile Hermès, the director of the firm at the time, had purchased a Han Dynasty piece for his collection: an ornament for a horse's headgear engraved with a butterfly guarded by a group of peculiar angels. The ornament was a symbol of transformation and metamorphosis: the butterfly accompanied the horseman as he rode to the Isle of the Immortals. In 1904 Thérèse Rentz, one of Fuller's imitators, had performed a dance entitled *La Loïe Fuller on Horseback*, a show photographed by Louis-Jean Delton in which Pegasus was transported to the Belle Époque. Thirty years later, Hermès produced one of its first silk scarves in which the horse, the firm's icon, was associated with a butterfly and silk in a symbolic, spiritual journey. Dyed in the fluorescent colours that Fuller used for her performances, these scarves offer one of the most exquisite examples of the relationship between art and fashion.

•

Fuller's legacy and the repercussions of her work on today's artists require their own study, but that would be the theme of another exhibition. Even so, the diverse perspectives and rich variety of interpretations associated with her legacy clearly testify to the importance and lasting influence of Loïe Fuller.

List of Works

1
Koloman Moser
Loïe Fuller im Tanz der Erzengel
[Loïe Fuller in the Archangel
Dance], 1900
Facsimile
7 x 9"
Albertina, Vienna

2
Loïe Fuller with Her Father,
ca. 1866
Facsimile*
The Jerome Robbins Dance
Division, The New York Public
Library for the Performing
Arts, Astor, Lenox and Tilden
Foundations

3
Harry C. Ellis
Loïe Fuller with Her Mother,
ca. 1907
Vintage photographic print
9 ³/₄ x 7 ⁵/₈"
The Jerome Robbins Dance
Division, The New York Public
Library for the Performing
Arts, Astor, Lenox and Tilden
Foundations

4
*"Loïe Fuller/Cléo de Mérode.
Philosophie de la danse. Origine
des danses sacrées"* [Philosophy
of Dance. Origin of the Sacred
Dances], 1903
Revue Illustrée, 22 (1903)
12 ¹/₂ x 9 ¹/₄ x ¹/₈"
Bibliothèque-musée de l'Opéra-
Bibliothèque nationale de France

5
Faber
Loïe Fuller in San Francisco,
ca. 1894
Facsimile
The Jerome Robbins Dance
Division, The New York Public
Library for the Performing
Arts, Astor, Lenox and Tilden
Foundations

6
Reutlinger (Paris)
*Loïe Fuller in Costume for the
Butterfly Dance*, 1895
Vintage photographic print
6 ¹/₂ x 4 ¹/₂"
Maryhill Museum of Art Collection

7
Reutlinger (Paris)
*Loïe Fuller in Costume for the
Butterfly Dance*, ca. 1893
Autograph and newspaper
clipping
8 ¹/₄ x 5"
Maryhill Museum of Art Collection

8
Portrait of Alice A. Weston,
ca. 1902
Printer's proof
5 ¹/₄ x 3 ¹/₂"
Musée Rodin, Paris
© musée Rodin, Paris

9
Reutlinger (Paris)
Loïe Fuller, 1893
Postcard
6 ¹/₂ x 4 ¹/₂"
Maryhill Museum of Art Collection

10
Illustrated Supplement of
L'Écho de Paris, 1894
12 ⁷/₈ x 9 ⁷/₈"
Brygida Maria Ochaim

11
Loïe Fuller. Folies Bergère, 1892
Vintage photographic print
12 ¹/₄ x 9 ¹/₂"
Bibliothèque-musée de l'Opéra-
Bibliothèque nationale de France

12
Van Bosch
Loïe Fuller, ca. 1892
Vintage photographic print
6 ¹/₂ x 4 ¹/₄"
Bibliothèque-musée de l'Opéra-
Bibliothèque nationale de France

13
Miss Loïe Fuller, ca. 1893
Souvenir of the Folies Bergère
Vintage photographic print
6 ¹/₂ x 4 ¹/₄"
Bibliothèque-musée de l'Opéra-
Bibliothèque nationale de France

14
*Loïe Fuller in Costume for the
Butterfly Dance*, ca. 1895
Vintage photographic print
3 x 1 ⁵/₈"
Collection Felix Potin.
Bibliothèque-musée de l'Opéra-
Bibliothèque nationale de France

15
"Griechischer Tanz von Loïe Fuller"
[Loïe Fuller's Greek Dance], n.d.
Moderne Kunst, XVI
15 ³/₄ x 11 ¹/₂"
Brygida Maria Ochaim

16
Napoleon Sarony
Loïe Fuller, 1887
Facsimile
The Jerome Robbins Dance
Division, The New York Public
Library for the Performing
Arts, Astor, Lenox and Tilden
Foundations

17
Loïe Fuller, 1893
Vintage photographic print
6 x 4"
Maryhill Museum of Art Collection

18
Benjamin J. Falk
Loïe Fuller Posing in Her Salome Costume above a Floor Lighting Fixture, 1896
Vintage photographic print
9 ¾ x 7 ¾"
The Jerome Robbins Dance Division, The New York Public Library for the Performing Arts, Astor, Lenox and Tilden Foundations

19
Langfier
Loïe Fuller: Serpentine Dance, 1893
Vintage albumen print
6 ¾ x 4 ¼"
Musée Rodin, Paris
© musée Rodin, Paris

20
Butterfly Dance, ca. 1898
Vintage photographic print
7 ½ x 9 ⅝"
The Jerome Robbins Dance Division, The New York Public Library for the Performing Arts, Astor, Lenox and Tilden Foundations

21
Langfier
Loïe Fuller Performing the Butterfly Dance, 1896
Vintage albumen print
4 ¼ x 6 ¾"
Musée Rodin, Paris
© musée Rodin, Paris

22
Théodore Rivière
White Dance, 1898
Vintage photographic print
4 ⅝ x 7 ⅜"
The Jerome Robbins Dance Division, The New York Public Library for the Performing Arts, Astor, Lenox and Tilden Foundations

23
Arsène Alexandre
"Le Théâtre de La Loïe Fuller"
[The Theatre of La Loïe Fuller], 1900
Le Théâtre, special issue (*La Danse à l'Exposition*), vol. II, no. 40 (August 1900)
14 ⅛ x 11"
Bibliothèque-musée de l'Opéra–Bibliothèque nationale de France

24
S. J. Beckett
Loïe Fuller Performing the Lily Dance Outdoors, 1898
Vintage photographic print
3 ¼ x 4 ⅛"
Maryhill Museum of Art Collection

25
Pierre Roche
Loïe Fuller, ca. 1900
Bronze
18 (ø) x 5 ¼"
Maryhill Museum of Art Collection

26
E. Bosanquet
Loïe Fuller Waltz, 1902
Musical score
12 x 9 ⅞"
The Jerome Robbins Dance Division, The New York Public Library for the Performing Arts, Astor, Lenox and Tilden Foundations

27
Jules Chéret
Folies Bergère. Loïe Fuller, 1897
Advertising poster
51 ¼ x 36 x 2" (framed)
Maryhill Museum of Art Collection

28
Loïe Fuller
Le Langage de la danse
[The Language of Dance], n.d.
Two pages, typescript
8 ⅜ x 10 ¾"
The Jerome Robbins Dance Division, The New York Public Library for the Performing Arts, Astor, Lenox and Tilden Foundations

29
Loïe Fuller
Théorie de la danse
[Theory of Dance], n.d.
Three pages, typescript
10 ¾ x 8 ⅜"
The Jerome Robbins Dance Division, The New York Public Library for the Performing Arts, Astor, Lenox and Tilden Foundations

30
Jean-Léon Gérôme
Loïe Fuller, 1893
Oil on panel
19 ¾ x 17"
Musée Georges Garret

31
Jean-Léon Gérôme
Loïe Fuller, 1893
Oil on canvas
19 ¾ x 17"
Musée Georges Garret

32
Jean-Léon Gérôme
La Danse [The Dance], 1893
White marble
34 ¼"
Musée Georges Garret

33
Théodore Rivière
Loïe Fuller dansant
[Loïe Fuller Dancing], n.d.
Bronze
10 x 6 ½ x 4 ½"
Maryhill Museum of Art Collection

34
Théodore Rivière
Dance du Lys [Lily Dance], 1898
Bronze
10 ½ x 6 ½ x 4"
Maryhill Museum of Art Collection

35
Loïe Fuller dansant
[Loïe Fuller Dancing], n.d.
Plaster
18 (ø) x 5 ¼"
Maryhill Museum of Art Collection

36
Danse serpentine
[Serpentine Dance], 1900
Tinted film, 1 min 40 s
Performer: Mlle Bob Walter
Director: Alice Guy (attributed)
Gaumont Pathé Archives

37
Parodie d'une danse de Loïe Fuller
[Parody of a Loïe Fuller Dance],
1907
Black and white film, 1 min
Performer: Little Tich
Gaumont Pathé Archives

38
*Danse serpentine à la manière
de Loïe Fuller* [Serpentine Dance
in the Style of Loïe Fuller], 1900
Black and white film, 1 min 15 s
Gaumont Pathé Archives

39
Les Papillons japonais
[The Japanese Butterflies], 1908
Film, hand-coloured by Segundo
de Chomón, 4 min 26 s
Production: Pathé Frères
Courtesy Filmoteca de Catalunya

40
Création de la serpentine
[Creation of the Serpentine
Dance], 1908
Black and white film, 5 min 14 s
Director: Segundo de Chomón
Courtesy Filmoteca de Catalunya

41
Danse fleur de lotus [Lotus
Flower Dance], 1896
Black and white film, 1 min 5 s
Performer: Mlle Bob Walter
Director: Alice Guy (attributed)
Gaumont Pathé Archives

42
Danse des papillons
[Butterfly Dance], 1896
Black and white film, 30 s
Performer: Mlle Bob Walter
Director: Alice Guy (attributed)
Gaumont Pathé Archives

43
Farfalle [Butterflies], 1907
Tinted film, 6 min 32 s
Lobster Films

44
Loïe Fuller
L'Oiseau noir [The Black Bird], n.d.
Facsimile
The Jerome Robbins Dance
Division, The New York Public
Library for the Performing
Arts, Astor, Lenox and Tilden
Foundations

45
Loïe Fuller
Notes for an Essay on Dance, n.d.
Facsimile
The Jerome Robbins Dance
Division, The New York Public
Library for the Performing
Arts, Astor, Lenox and Tilden
Foundations

46
Eugène Druet
*Loïe Fuller in Costume for the
Archangel Dance*, 1901
Vintage gelatin silver print
15 x 11"
Musée Rodin, Paris
© musée Rodin, Paris

47
Harry C. Ellis (attributed)
Loïe Fuller Dancing in a Park,
1909–1914
Facsimile
6 ¾ x 9"
Paris, Musée d'Orsay
© RMN-Grand Palais (musée
d'Orsay)/Hervé Lewandowski

48
Harry C. Ellis
Loïe Fuller Dancing, n.d.
Vintage salt print
7 ⅝ x 9 ½"
Musée Rodin, Paris
© musée Rodin, Paris

49
Eugène Druet
Loïe Fuller Dancing, 1900
Vintage gelatin silver print
15 ¾ x 12"
Musée Rodin, Paris
© musée Rodin, Paris

50
Eugène Druet
*Loïe Fuller Posing on a Table
for the Archangel Dance*, 1901
Vintage gelatin silver print
15 ¾ x 12"
Musée Rodin, Paris
© musée Rodin, Paris

51
Eugène Druet
*Loïe Fuller Posing on a Table
for the Archangel Dance*, 1901
Vintage gelatin silver print
15 ¾ x 12"
Musée Rodin, Paris
© musée Rodin, Paris

52
Eugène Druet
Loïe Fuller Dancing, 1900
Vintage gelatin silver print
15 ¾ x 12"
Musée Rodin, Paris
© musée Rodin, Paris

53
Eugène Druet
*Loïe Fuller Posing on a Table
for the Archangel Dance*, 1901
Vintage gelatin silver print
15 ¾ x 12"
Musée Rodin, Paris
© musée Rodin, Paris

54
Eugène Druet
*Loïe Fuller Posing on a Table
for the Archangel Dance*, 1901
Vintage gelatin silver print
15 ¾ x 12"
Musée Rodin, Paris
© musée Rodin, Paris

55
Loïe Fuller
Danse ultra violette
[Ultraviolet Dance], n.d.
Three pages, typescript
10 ¾ x 8 ⅜"
The Jerome Robbins Dance
Division, The New York Public
Library for the Performing
Arts, Astor, Lenox and Tilden
Foundations

56
*L'Hippodrome. Le Petit
Orchestre*, 1907
Performance programme
8 ¾ x 5 ⅝"
The Jerome Robbins Dance
Division, The New York Public
Library for the Performing
Arts, Astor, Lenox and Tilden
Foundations

57
Loïe Fuller
*Notebook with Draft of a
"Lecture on Radium"*, 1907–1911
9 x 7 ¼ x ½" (closed)
The Jerome Robbins Dance
Division, The New York Public
Library for the Performing
Arts, Astor, Lenox and Tilden
Foundations

58
Eugène Druet
Loïe Fuller Dancing, n.d.
Vintage gelatin silver print
15 ¾ x 12"
Musée Rodin, Paris
© musée Rodin, Paris

59
Harry C. Ellis
Loïe Fuller Posing, n.d.
Vintage aristotype
7 ½ x 9 ½"
Musée Rodin, Paris
© musée Rodin, Paris

60
Langfier
*Delilah Fuller, Loïe Fuller and
Mr. & Mrs. Flammarion*, n.d.
Vintage photographic print
9 ⅝ x 8"
The Jerome Robbins Dance
Division, The New York Public
Library for the Performing
Arts, Astor, Lenox and Tilden
Foundations

61
*Letter from Camille Flammarion
to Loïe Fuller*, 1915
8 x 5"
The Jerome Robbins Dance
Division, The New York Public
Library for the Performing
Arts, Astor, Lenox and Tilden
Foundations

62
Gabrielle Flammarion
*Flammarion Home and
Observatory*, 1927
Postcard
3 ½ x 5 ⅜"
Maryhill Museum of Art Collection

63
Isaiah West Taber
*Loïe Fuller Performing the Final
Toss and Enveloping Twirl of Her
Veil in the Lily Dance*, ca. 1902
Facsimile
7 x 5"
Paris, Musée d'Orsay
© Musée d'Orsay, Dist. RMN-
Grand Palais/Patrice Schmidt

64
*Loïe Fuller, Auguste Rodin and
Gabrielle Bloch*, ca. 1913
Vintage photographic print
4 x 5"
The Jerome Robbins Dance
Division, The New York Public
Library for the Performing
Arts, Astor, Lenox and Tilden
Foundations

65
Loïe Fuller
Notes on Auguste Rodin, n.d.
Three pages, holograph
P. 2: 8 ¼ x 5 ⅜"; p. 3: 8 ¼ x 5 ¼";
p. 4: 8 ½ x 6 ½"
The Jerome Robbins Dance
Division, The New York Public
Library for the Performing
Arts, Astor, Lenox and Tilden
Foundations

66
Isaiah West Taber
Loïe Fuller Dancing, ca. 1900
Printer's proof
13 ¾ x 9"
Paris, Musée d'Orsay
© Musée d'Orsay, Dist. RMN-
Grand Palais/Patrice Schmidt

67
*Letter from Loïe Fuller to
Auguste Rodin*, 1915
Four pages, holograph
9 ⅝ x 8"
The Jerome Robbins Dance
Division, The New York Public
Library for the Performing
Arts, Astor, Lenox and Tilden
Foundations

68
Dance of the Eyes, ca. 1907
Vintage photographic print
4 ⅜ x 7 ⅛"
The Jerome Robbins Dance
Division, The New York Public
Library for the Performing
Arts, Astor, Lenox and Tilden
Foundations

69
Loïe Fuller, n.d.
Vintage photographic print
5 ¾ x 3 ¾"
Maryhill Museum of Art Collection

70
Loïe Fuller Dancing, ca. 1905
Printer's proof
8 ⅝ x 11 ⅛"
Musée Rodin, Paris
© musée Rodin, Paris

71
R. Moreau (attributed)
Loïe Fuller with Veil, 1900
Vintage calotype
6 ⅜ x 5"
Musée Rodin, Paris
© musée Rodin, Paris

72
Loïe Fuller
Autobiography, n.d.
Facsimile
The Jerome Robbins Dance
Division, The New York Public
Library for the Performing
Arts, Astor, Lenox and Tilden
Foundations

73
Loïe Fuller with Students, ca. 1908
Vintage photographic print
7 ¼ x 9 ⅜"
Maryhill Museum of Art Collection

74
R. Moreau
Loïe Fuller, n.d.
Vintage photographic print
5 ⅝ x 4"
Maryhill Museum of Art Collection

75
Students of Loïe Fuller, n.d.
Vintage photographic print
5 x 7"
Bibliothèque-musée de l'Opéra–
Bibliothèque nationale de France

76
Loïe Fuller
Notes on Ève Curie, n.d.
10 ⅛ x 8 ¼"
The Jerome Robbins Dance
Division, The New York Public
Library for the Performing
Arts, Astor, Lenox and Tilden
Foundations

77
Ève Curie, n.d.
Facsimile
The Jerome Robbins Dance
Division, The New York Public
Library for the Performing
Arts, Astor, Lenox and Tilden
Foundations

78
*Letters from Marie Curie to
Loïe Fuller*, 1924
10 x 8"
The Jerome Robbins Dance
Division, The New York Public
Library for the Performing
Arts, Astor, Lenox and Tilden
Foundations

79
Harry C. Ellis
Loïe Fuller Dancing in Her Paris Studio, ca. 1914
Vintage salt print
9 ½ x 7 ⅝"
Musée Rodin, Paris
© musée Rodin, Paris

80
Portrait of Loïe Fuller, ca. 1914
Vintage photographic print
5 ¼ x 3 ⅜"
Musée Rodin, Paris
© musée Rodin, Paris

81
Letter from Loïe Fuller to Gabrielle Bloch, n.d.
Facsimile (three pages, holograph)
The Jerome Robbins Dance Division, The New York Public Library for the Performing Arts, Astor, Lenox and Tilden Foundations

82
Harry C. Ellis
Students of Loïe Fuller Dancing, 1914
Vintage gelatin silver print
4 ½ x 6 ⅝"
Musée Rodin, Paris
© musée Rodin, Paris

83
Harry C. Ellis
Students of Loïe Fuller Dancing, 1914
Vintage gelatin silver print
4 ½ x 6 ½"
Musée Rodin, Paris
© musée Rodin, Paris

84
Harry C. Ellis
Students of Loïe Fuller, 1914
Vintage gelatin silver print
4 ½ x 6 ⅜"
Musée Rodin, Paris
© musée Rodin, Paris

85
Harry C. Ellis
The Muses Performing in Camille Flammarion's Garden at Juvisy, n.d.
Vintage photographic print
4 ½ x 6 ¾"
The Jerome Robbins Dance Division, The New York Public Library for the Performing Arts, Astor, Lenox and Tilden Foundations

86
Loïe Fuller and Her Muses Performing A Night on Mont Chauve *at San Francisco's Festival Hall*, 1915
Vintage photographic print
5 x 6 ⅞"
The Jerome Robbins Dance Division, The New York Public Library for the Performing Arts, Astor, Lenox and Tilden Foundations

87
Loïe Fuller Dancing before the Sphinx at Giza, 1914
Vintage photographic print
9 x 6 ½"
The Jerome Robbins Dance Division, The New York Public Library for the Performing Arts, Astor, Lenox and Tilden Foundations

88
Eugène Druet
Loïe Fuller Performing the Archangel Dance, 1901
Vintage photographic print
6 x 4"
Maryhill Museum of Art Collection

89
R. Moreau
Loïe Fuller Dancing, n.d.
Printer's proof
6 ¼ x 4 ¼"
Musée Rodin, Paris
© musée Rodin, Paris

90
Letter from Alma Spreckels to Loïe Fuller, 1914
10 ⅛ x 6 ⅞"
Maryhill Museum of Art Collection

91
Loïe Fuller and Rodin's The Kiss, ca. 1916
Vintage photographic print
10 x 8"
The Jerome Robbins Dance Division, The New York Public Library for the Performing Arts, Astor, Lenox and Tilden Foundations

92
Loïe Fuller et son École de Danse [Loïe Fuller and Her Dance School], 1914
Programme
8 ½ x 5 ⅜" (closed)
The Jerome Robbins Dance Division, The New York Public Library for the Performing Arts, Astor, Lenox and Tilden Foundations

93
Harry C. Ellis
Loïe Fuller Posing during Her Show, 1914
Vintage aristotype from duplicate negative
7 ⅛ x 4 ⅞"
Paris, Musée d'Orsay
© Musée d'Orsay, Dist. RMN-Grand Palais/Patrice Schmidt

94
Autographed Photo by Loïe Fuller, n.d.
6 ⅞ x 4"
The Jerome Robbins Dance Division, The New York Public Library for the Performing Arts, Astor, Lenox and Tilden Foundations

95
Letter from Queen Marie of Romania to Loïe Fuller, 1917
7 ¼ x 5 ⅜"
Maryhill Museum of Art Collection

96
Letter from Loïe Fuller to Queen Marie of Romania, n.d.
Facsimile
The Jerome Robbins Dance Division, The New York Public Library for the Performing Arts, Astor, Lenox and Tilden Foundations

97
Letter from Queen Marie of Romania to Loïe Fuller, 1922
7 ½ x 6 ½"
Maryhill Museum of Art Collection

98
Harry C. Ellis
Loïe Fuller Seated on a Throne, 1914
Vintage gelatin silver print
4 ¼ x 3 ⅜"
Paris, Musée d'Orsay
© Musée d'Orsay, Dist. RMN-Grand Palais/Patrice Schmidt

99
Loïe Fuller's Passport, 1923
9 x 9"
Maryhill Museum of Art Collection

100
Students of Loïe Fuller in Egypt,
1914
Vintage photographic print
7 3/8 x 8 7/8"
Maryhill Museum of Art Collection

101
Student of Loïe Fuller Performing
Prometheus, n.d.
Vintage photographic print
5 x 7 1/2"
Bibliothèque-musée de l'Opéra–
Bibliothèque nationale de France

102
Henri Manuel
Loïe Fuller, n.d.
Vintage photographic print
6 1/2 x 4 1/4"
Bibliothèque-musée de l'Opéra–
Bibliothèque nationale de France

103
Harry C. Ellis
*Loïe Fuller after Undergoing
Surgery to Remove a Breast
Tumour*, 1925
Vintage photographic print
7 x 9 1/4"
The Jerome Robbins Dance
Division, The New York Public
Library for the Performing Arts,
Astor, Lenox and Tilden
Foundations

104
Harry C. Ellis
*Loïe Fuller Recovering in the
Hospital*, ca. 1925
Vintage photographic print
7 x 6 7/8"
Maryhill Museum of Art Collection

105
Harry C. Ellis
En double expression
[Double Expression], 1925
Vintage photographic print
6 7/8 x 9 1/4"
The Jerome Robbins Dance
Division, The New York Public
Library for the Performing
Arts, Astor, Lenox and Tilden
Foundations

106
*Loïe Fuller and Her Students
in Egypt*, 1914
Vintage photographic print
3 1/2 x 5 3/4"
Maryhill Museum of Art Collection

107
*Loïe Fuller, Queen Marie and
Princess Ileana of Romania*, 1925
Vintage photographic print
4 x 6"
Maryhill Museum of Art Collection

108
*Letter from Samuel Hill to Loïe
Fuller*, 1927
11 x 8 1/2"
Maryhill Museum of Art Collection

109
P. Delbo
Loïe Fuller on Her Deathbed, 1928
Vintage photographic print
7 1/8 x 9 1/4"
Maryhill Museum of Art Collection

110
Le Lys [The Lily], 1934
Black and white film, 3 min
Performer: Miss Baker
Set design: George R. Busby
Art director: Gab Sorère
(pseudonym of Gabrielle Bloch)
Music: Prelude to *Le Déluge* by
Camille Saint-Saëns
Cinémathèque de la danse, Paris

111
Loïe Fuller. The Sphinx-Egypt, 1914
Facsimile
The Jerome Robbins Dance
Division, The New York Public
Library for the Performing
Arts, Astor, Lenox and Tilden
Foundations

112
Eugène Druet
Loïe Fuller on Stage, n.d.
Vintage gelatin silver print
15 1/4 x 11"
Musée Rodin, Paris
© musée Rodin, Paris

113
Stereoscopic photographs, n.d.
3 1/2 x 6 1/2" (each)
Filmoteca Española

114
Louis-Jean Delton (junior)
Mlle Thérèse Rentz in La Loïe
Fuller on Horseback *(a Show
Featuring Pegasus Set in the
Belle Époque Years)*, 1904
Photographic print
40 1/8 x 48 3/4"
Archives Hermès

115
La Cavalière ailée
[The Winged Horsewoman],
ca. 1934
Silk muslin shawl made after a
photograph of Mlle Thérèse Rentz
taken by Louis-Jean Delton
(junior)
55 1/8 x 55 1/8"
Archives Hermès

116
Harry C. Ellis
*Loïe Fuller and Her Students at
the Entrance to Mme de Polignac-
Singer's Home (?)*, 1914
Vintage gelatin silver print
4 1/2 x 6 3/4"
Paris, Musée d'Orsay
© RMN-Grand Palais (Musée
d'Orsay)/Michèle Bellot

117
Harry C. Ellis
*Students of Loïe Fuller Dancing
in a Park*, 1914
Vintage gelatin silver print
4 1/2 x 6 1/2"
Paris, Musée d'Orsay
© Musée d'Orsay, Dist. RMN-
Grand Palais/Patrice Schmidt

118
Harry C. Ellis
*Loïe Fuller Posing with Her
Students before the Sphinx
at Giza*, 1914
Vintage aristotype (citrate print)
9 1/2 x 6 3/4"
Paris, Musée d'Orsay
© Musée d'Orsay, Dist. RMN-
Grand Palais/Patrice Schmidt

119
Harry C. Ellis (attributed)
*Loïe Fuller Posing with Her
Students in Athens*, 1914
Vintage aristotype (citrate print)
6 7/8 x 9 1/2"
Paris, Musée d'Orsay
© RMN-Grand Palais (Musée
d'Orsay)/Michèle Bellot

120
Harry C. Ellis
*Loïe Fuller and Her Muses
in Prince Troub's Garden*, 1914
Vintage photographic print
9 ³/₈ x 7"
The Jerome Robbins Dance
Division, The New York Public
Library for the Performing
Arts, Astor, Lenox and Tilden
Foundations

121
Hana
Performance of Pays des oiseaux
sacrés *[Land of the Sacred Birds]
at Paris' Théâtre national de
l'Opéra*, 1920
Vintage photographic print
8 ¹/₈ x 11 ¹/₂"
The Jerome Robbins Dance
Division, The New York Public
Library for the Performing
Arts, Astor, Lenox and Tilden
Foundations

122
Salón Variedades Programme, 1912
16 ³/₄ x 6 ¹/₄"
Filmoteca Española

123
Cinématographe Jouet, n.d.
6 ³/₄ x 3 ³/₈ x 3 ¹/₈"
Filmoteca Española

124
*Reel of Dancer Images for
Cinématographe Jouet*, n.d.
1 ⁵/₈ x 13 ³/₄"
Filmoteca Española

125
*Child's Mutoscope and Reel with
Serpentine Dance Sequence*, n.d.
7 ¹/₂ x 8 ¹/₄ x 4" and 6 ³/₄ (ø) x 2"
Cinematograph
Filmoteca Española

126
*Dancer Imitating Loïe Fuller
Performing the Butterfly Dance
at Night*, 1904
Vintage photographic print
6 x 4"
Maryhill Museum of Art Collection

127
Loïe Fuller, n.d.
Vintage photographic print
5 ³/₄ x 4"
Musée Rodin, Paris
© musée Rodin, Paris

128
R. Moreau (attributed)
Loïe Fuller with Veil, n.d.
Vintage calotype
6 x 4 ¹/₂"
Musée Rodin, Paris
© musée Rodin, Paris

129
R. Moreau (attributed)
*Loïe Fuller Posing with a Lighting
Device*, ca. 1900
Vintage photographic print
4 x 3 ³/₈"
Maryhill Museum of Art Collection

130
Beware of Imitations!, 2013
Digital video produced specifically
for this exhibition, 15 min
Director and camera operator:
La Ribot
Music and piano performance:
Carles Santos
Director of photography:
Valentín Álvarez
Assistant photographer:
Javier López
Art director: Soledad Seseña
Special effects: Camilo de Martino
Production manager:
Paz Santa Cecilia